TIME FRAMES
City Pictures

MICHAEL
SPANO

Introduction by Susan Kismaric

powerHouse Books
New York, NY

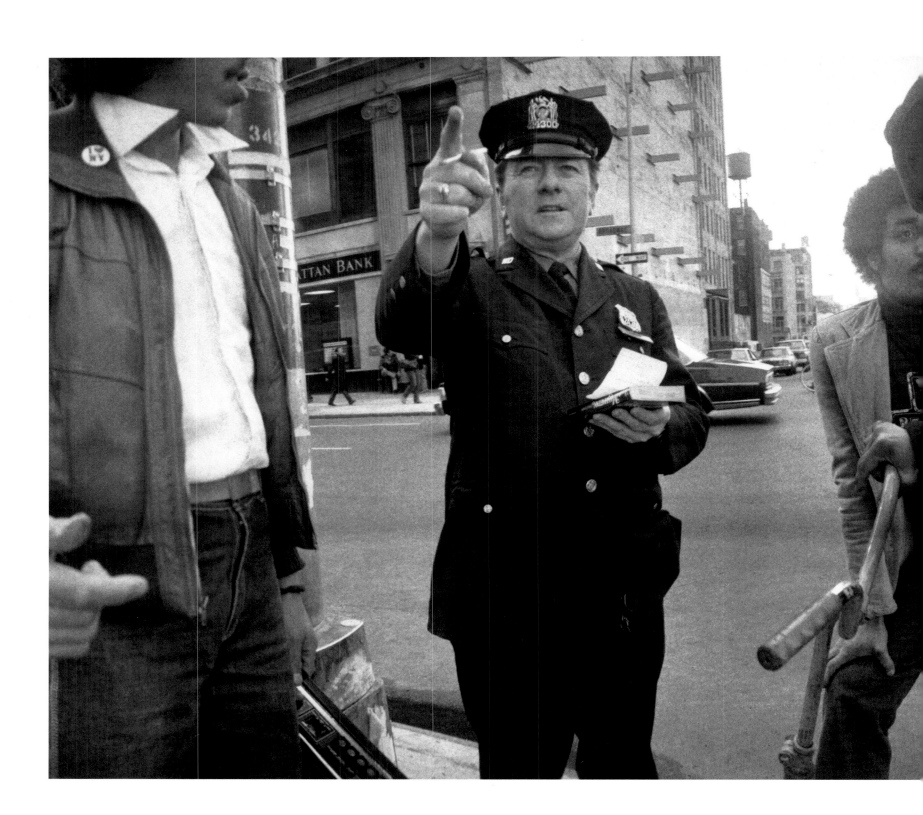

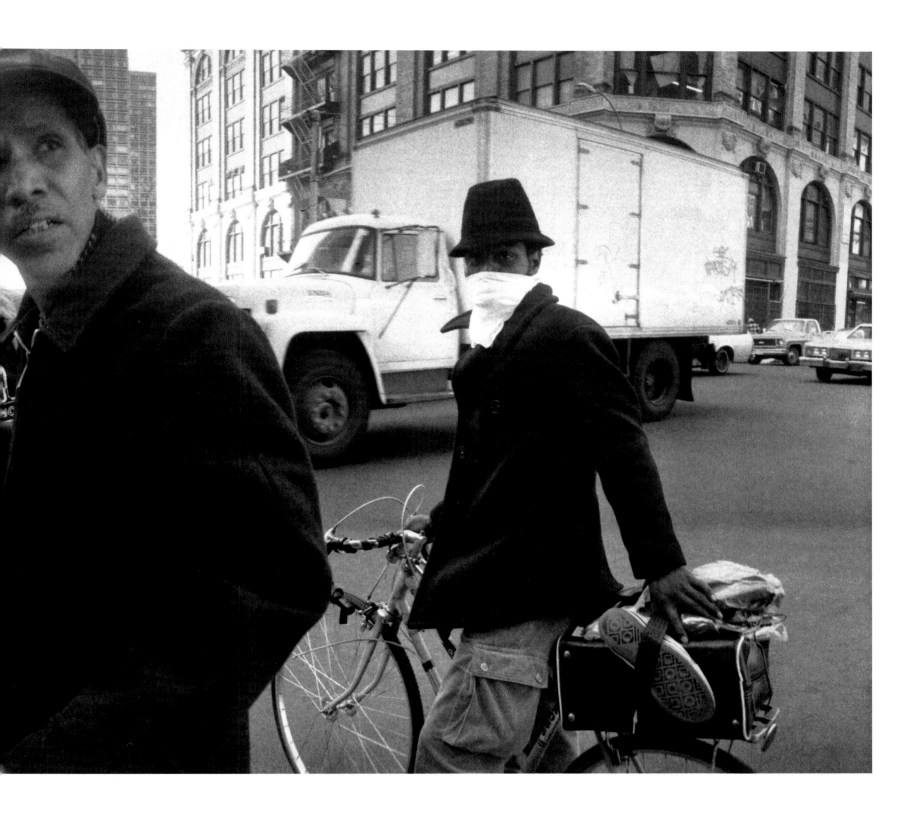

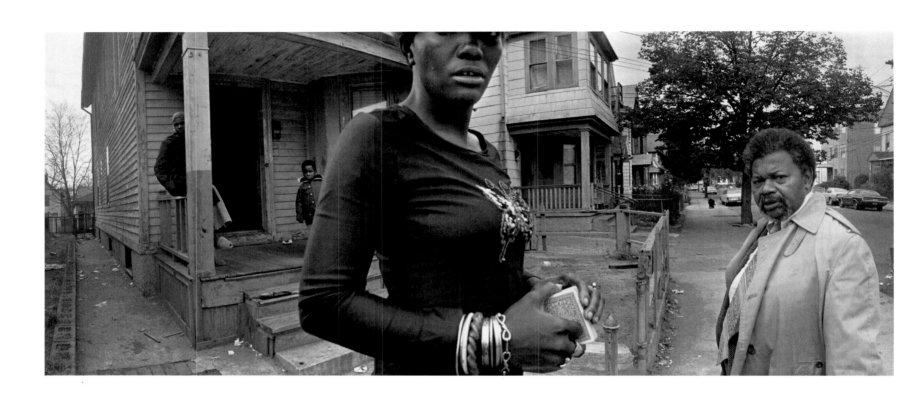

Contents

Introduction

Since the 35mm camera's invention in the mid-1920s, photographs made on city streets more or less have been made using this format. Primarily utilized for candid press photography, the 35mm fits easily in the hand. In addition to its portability, the rapid film rewind encourages a kind of "instant" vision. Physical movement, extreme characters, unnoticed gestures, and provocative juxtapositions—the "poetry" or "choreography" of street life—are transformed into pictures that depict the robust energy, satisfaction, and sorrow a city has to offer. Dependent on the intuitions, intelligence, and reflexes of the photographer, individual vision is determined by technique.

Michael Spano works against this tradition by photographing people on the street using four archaic and clumsy cameras. These include an extremely wide-field panoramic camera that spans 140° and provides up to three seconds of exposure during which he can try to anticipate how the action on the left side of the picture will relate to that on the right. Spano's grid pictures are made with an old sequence camera that he rebuilt to accommodate his desire to slow the exposure intervals, so that its eight frames can be consecutively exposed every four seconds. His multiple images are made on a single sheet of film that is exposed at least three different moments, again over varying snippets of time. Spano's more recent diptychs (and triptychs) are two in-camera exposures on a single sheet of 4x5 film made at different times and in different locations. Finally, his "solarized" portraitures isolate the subjects from their environments and extend the gestural or drawing quality of his work.

Spano's choice of cameras gives him a variety of options to construct his pictures, a process that is closer to drawing and sculpture, without the unwise sacrifice of the limitless spontaneity, good luck, and factuality that photography provides. By using these techniques, his photographs extend the narrative potential of photography—the photograph's ability to tell rich stories in which protagonists command our attention with tales and situations we are given the privilege to invent. His characters come from New York's ethnically, racially, and economically diverse population—businessmen, immigrants, street vendors, rich, poor, young, and old. Set against the architecture of many different sections of the city, his photographs vivify a place driven by energy and ambition—qualities that define the personal struggles of many New Yorkers.

In Spano's panoramic photographs, we see a view that the human eye cannot perceive. This is somewhat true of all photographs, but here it is the dominating aesthetic strategy, which Spano executes with ingenious simplicity. The panorama is the view of wide-screen movies, where we see landscapes or battlefields through the lens of a camera that unnaturally expands our peripheral vision by bringing into focus what our eye cannot. Applied to an urban setting filled with people, buildings, and traffic—the tangled web of commerce and domesticity—the conflation of elements rendered by the wide-view lens emphasizes our sense of congestion, proximity, and density to make the pictures consonant with our actual and interior experiences of city life. One of the most effective of these panoramas is the vertical photograph of a subway car filled with people on a hot summer day (p. 21). The "drawing" in the picture is particularly satisfying because Spano has used the shapes and forms, the lines of the figures and the parts of bodies to compose a whole that seduces us through its attention to all parts of the picture. This effect is further enhanced because the picture is a vertical in which the figures at back of the picture have been levitated to the foreground. The intensity of the gaze of the man in the bandanna at the top of the frame balances the stacked legs of children, an arm, and bodies in the lower part of the frame. This graphic finesse goes a long way to describe the physicality and psychology of a most common city scene.

The eight-exposure photographs recall the time-motion studies of Eadweard Muybridge (1830-1904), in which a stationary camera recorded the movement of animals and humans in quick successive exposures. Spano's eight-lens camera is hand-held, allowing him to move within a

prescribed space within a specific time frame. Unlike Muybridge, whose photographs were made to deconstruct time to analyze movement, Spano uses the successive exposures rather to create a collage of disparate, yet related pictures within which we see the same site from different vantage points within seconds. As in the panoramas, there is this kind of sculptural building of the picture that provides a view only available through photographic intervention. For example, the man in the white shirt and striped tie appears five times from different vantage points in an eight-frame sequence (p. 30). His dance across the picture brings him either more or less closer to us. The lingerie shop next door adds a provocation, as does the Asian woman who passes by. When we first see her, she is a "passerby;" in the last frame she walks alone and has our full attention. An unremarkable event has been photographed in such a way that it raises thoughts about the relation between men and women, the customs and cultures of countries of origin, and how this particular man and woman do or do not relate to each other. Like the device of cinematic cross cutting, the sum of the picture stirs mixed feelings within us. There is a building of tension, and an urge to complete the narrative.

In the solarizing of his negatives, the sensitive emulsion of the developed but unfixed film is exposed to naked light and developed again. The solarization technique, used extensively by Man Ray (1890-1976) in the 1920s, throws parts of the picture into a high key of brightness, creating cartoon-like shapes with ambiguous meanings. The image shows a reversal of tones; wherever there is a sharp edge, its contours are rimmed with black lines. Spano applies this technique to his "portraits"—individuals he has drawn from the crowd for special attention. It is a view of city dwellers as specters, shadowy half-people who are there and yet not there. While the presence of the seated man (p. 53) is firmly felt, he seems not entirely with us. So much photographic detail is withheld that he appears as a misguided X-ray. Without details and the barest of outlines, we can establish few certainties. Yet we are invited to create his interior self—to create a person.

In his recent diptychs made inside the camera, there is a simple juxtaposition of people, and people with things. The more extended narrative has been reduced to a boldly described one-on-one relationship. In setting two potential stories together, it is the continuity of form across the page that unites the work and allows us to compare and contrast. The line that divides the frame down the middle boldly emphasizes the pictures' separateness, and deftly guides us to understand the forced human relationships across the frame, or their absence.

Spano's act of transforming the world into pictures is imaginative, and his perspective wholly unexpected. His photographs are enjoyed less as windows onto events than as transformations of events. His joining of the irrefutable factual quality of photographic images with the reduction or distortion of natural forms into shape and line recalls the work of the image experimenters of the 1920s, such as Laszlo Moholy-Nagy (1895-1946) and Alexander Rodchenko (1891-1956). What's most surprising and gratifying is that Spano successfully reinvigorates an 80-year-old genre of photography by relying on historic techniques and technology.

There is sadness in the work—all these potential stories never to be recognized or recorded except in the minds and lives of a few, and some not at all. As the cliché goes, New York is a city of eight million stories. Michael Spano redeems the overwhelming numbers while lowering the odds by bringing our attention to some of them. In doing so, he encourages us to reconsider our relationship not only to the city, but to the individual lives of the people who live there.

—Susan Kismaric, Curator
Department of Photography
The Museum of Modern Art
June 2002

Panoramas

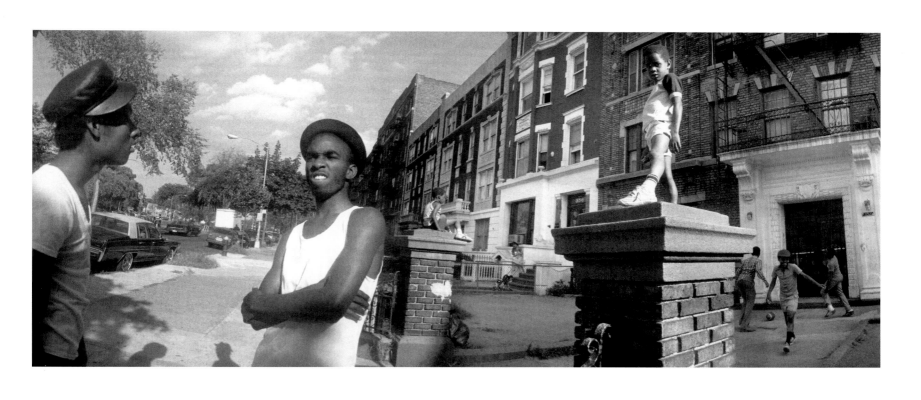

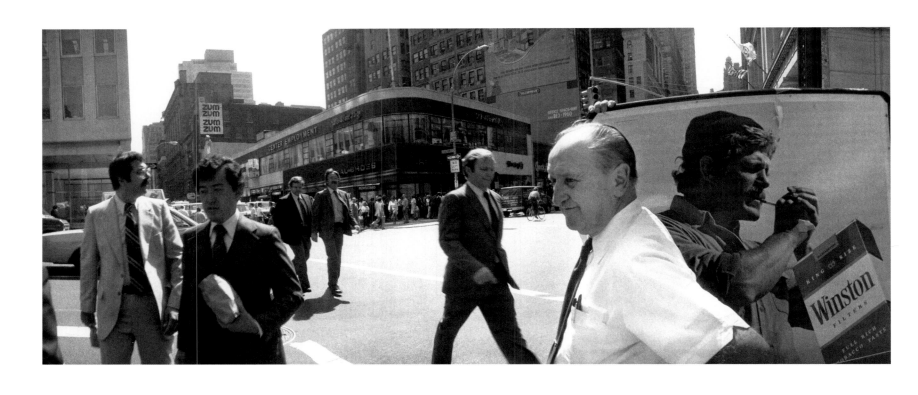

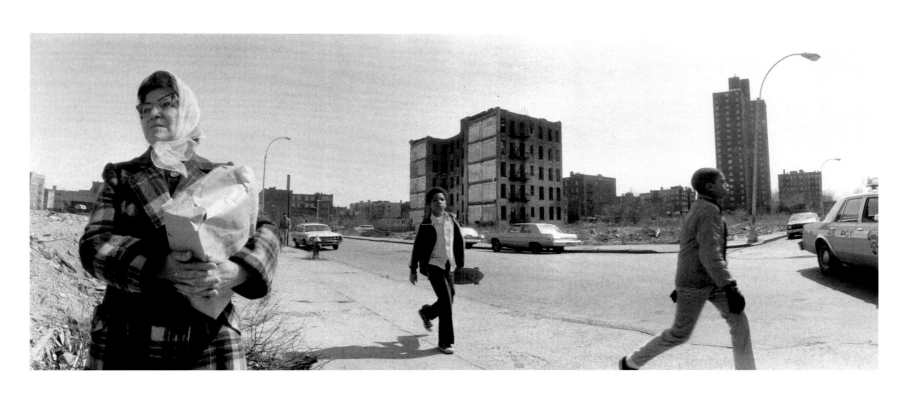

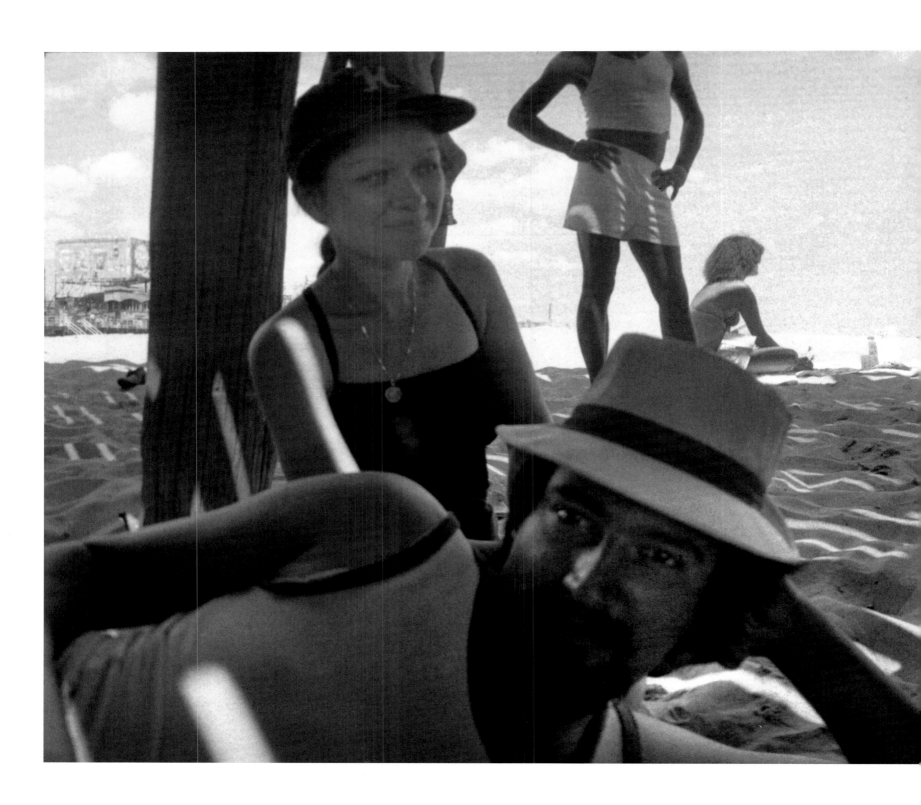

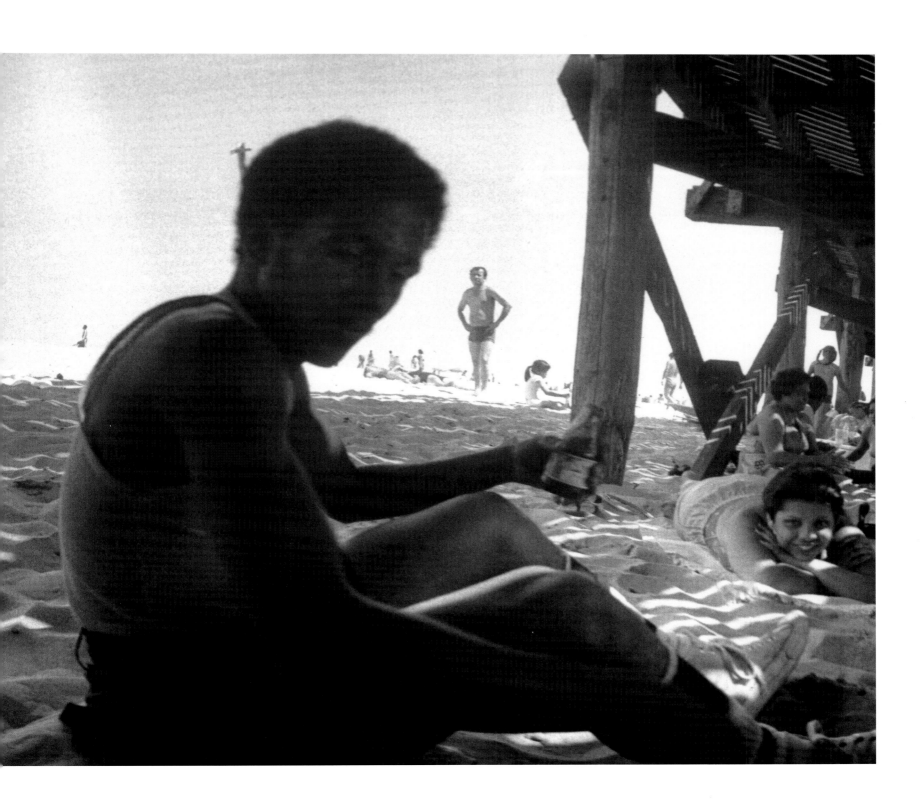

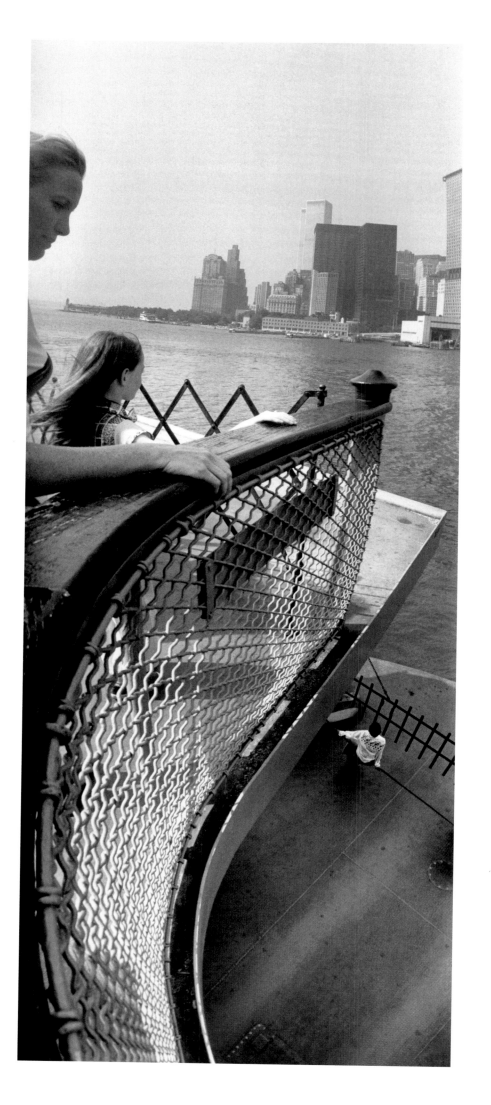

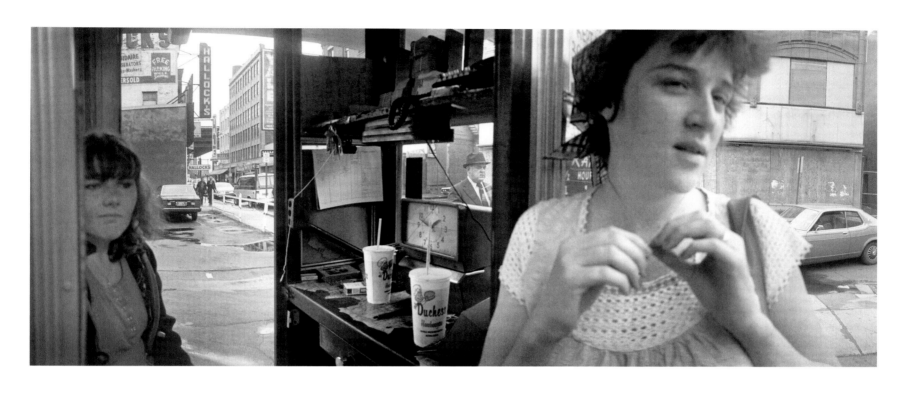

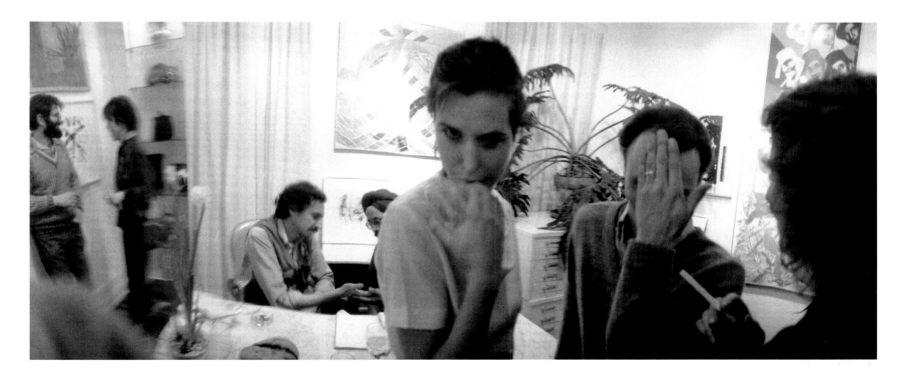

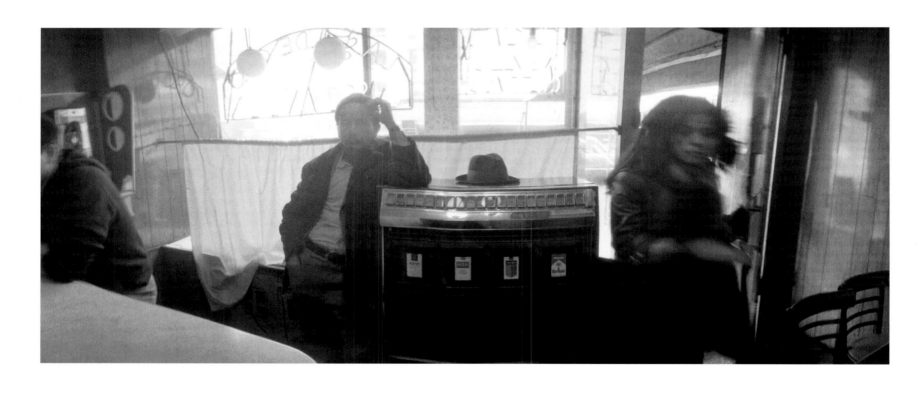

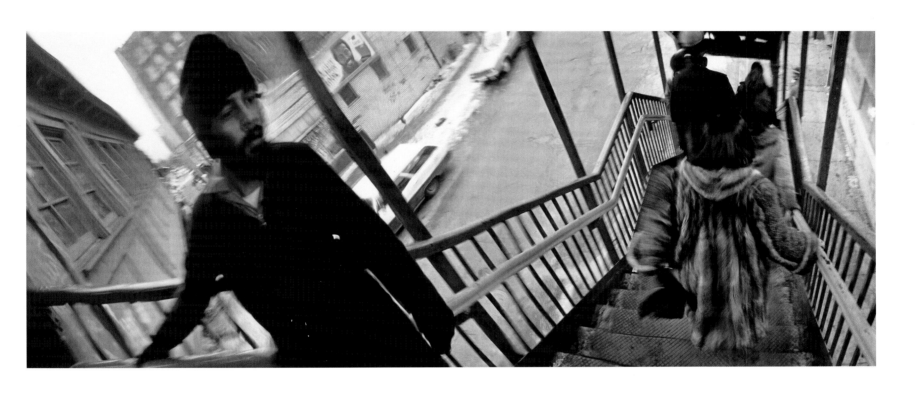

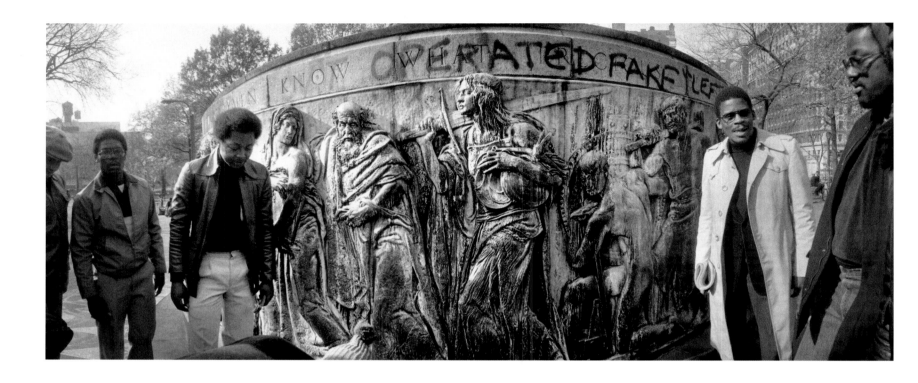

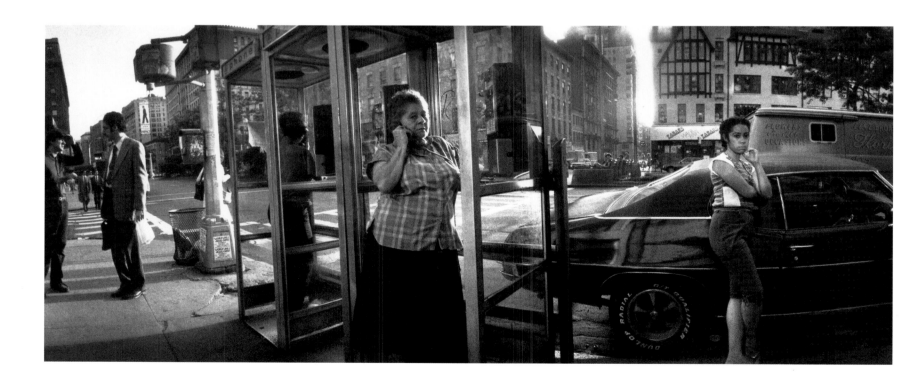

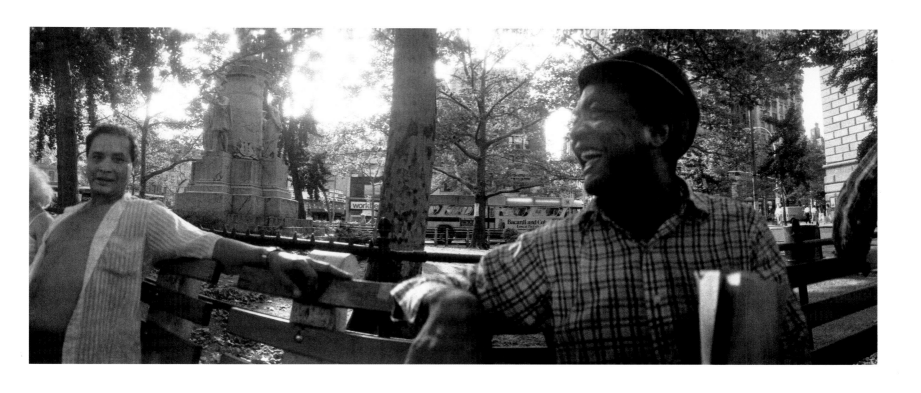

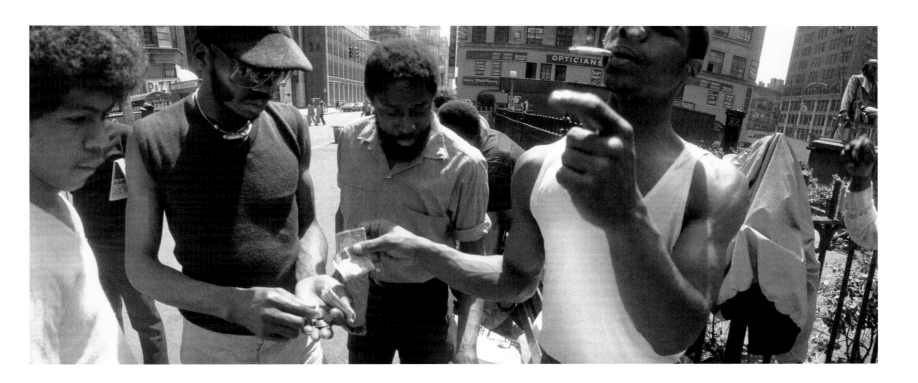

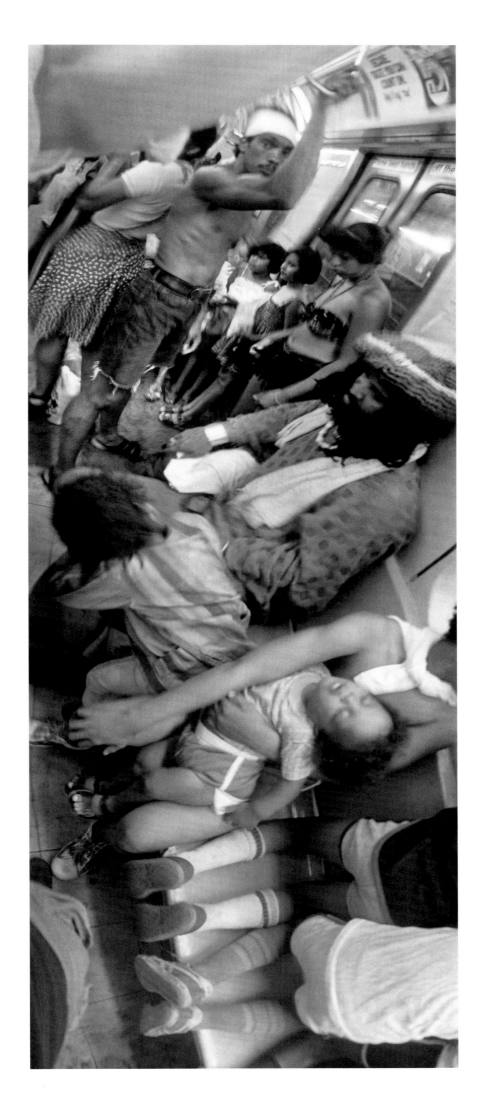

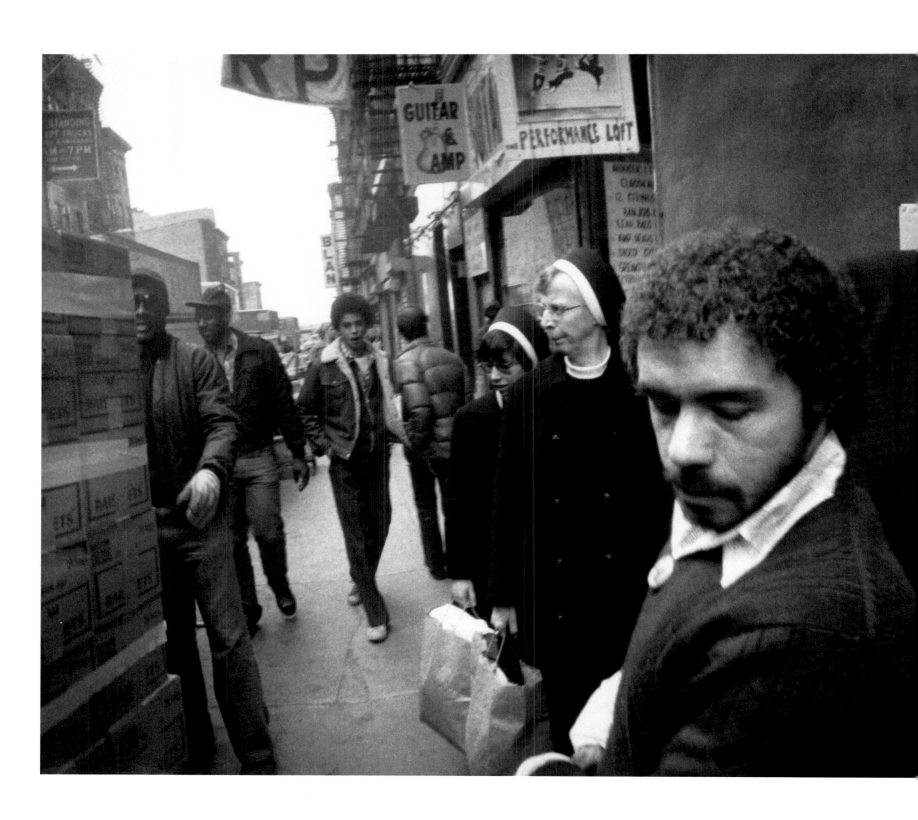

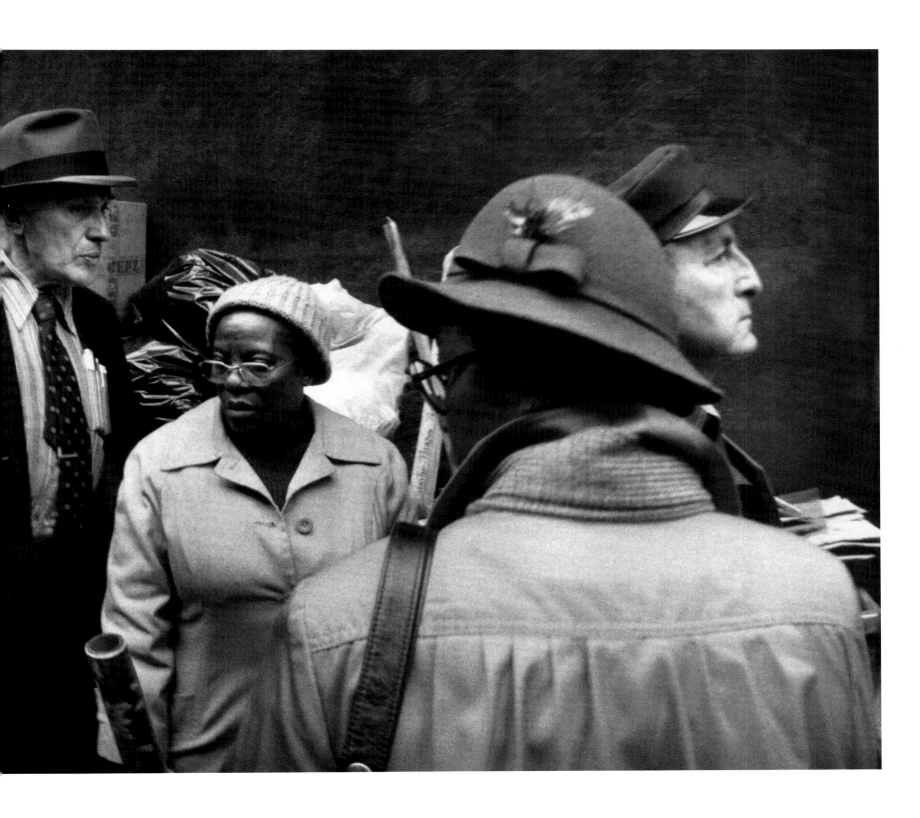

Grids

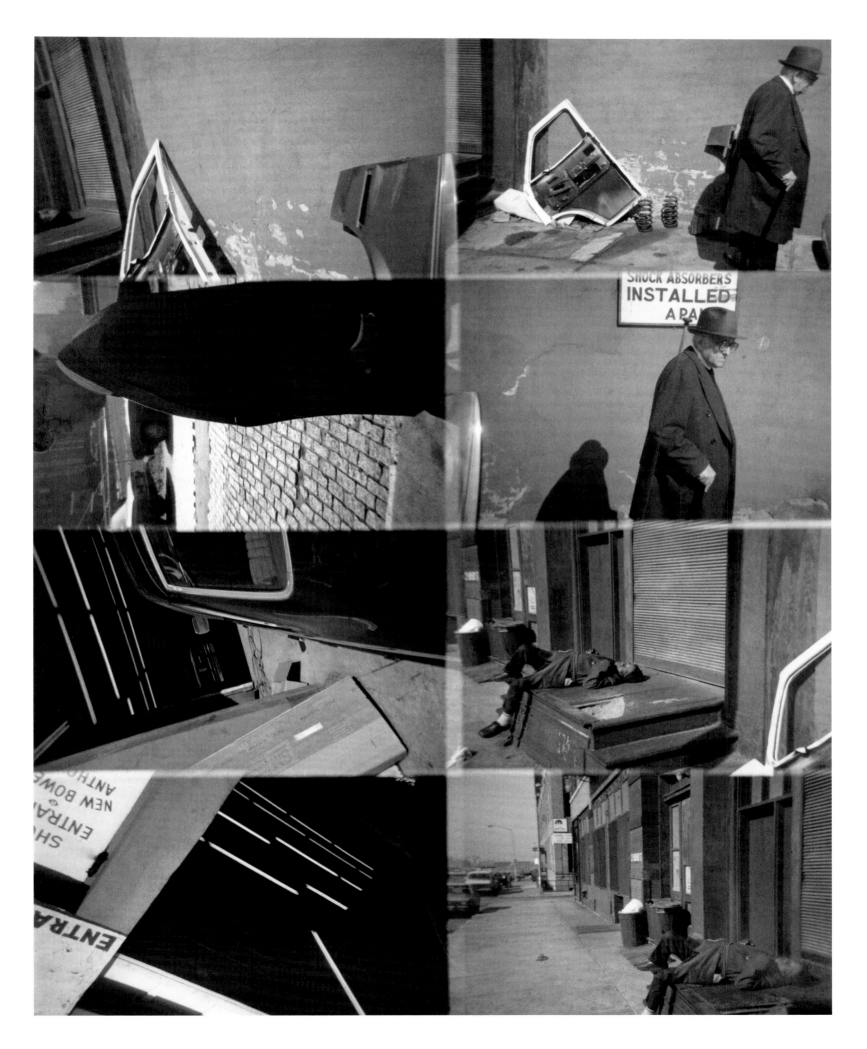

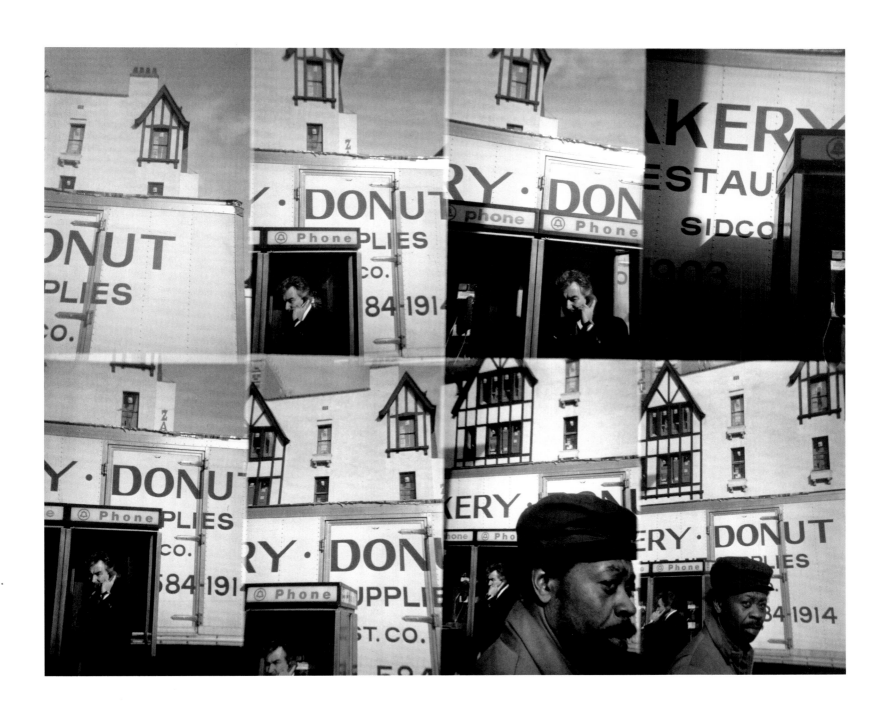

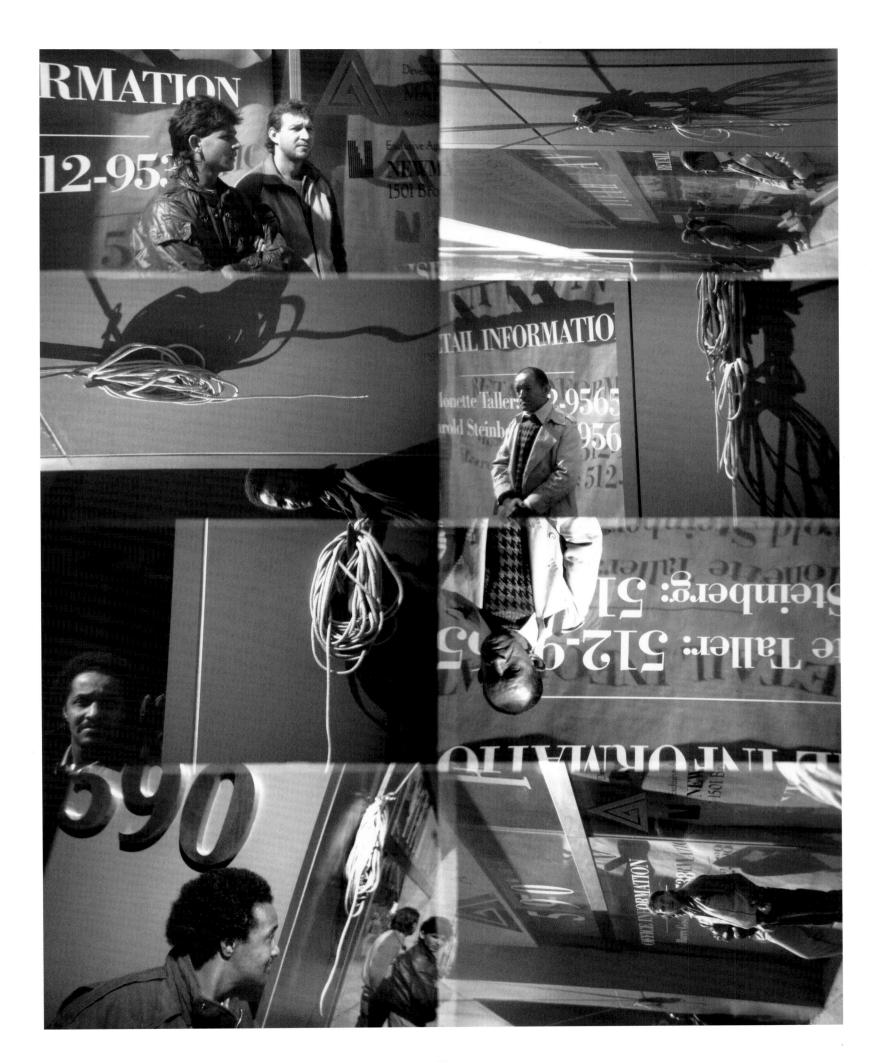

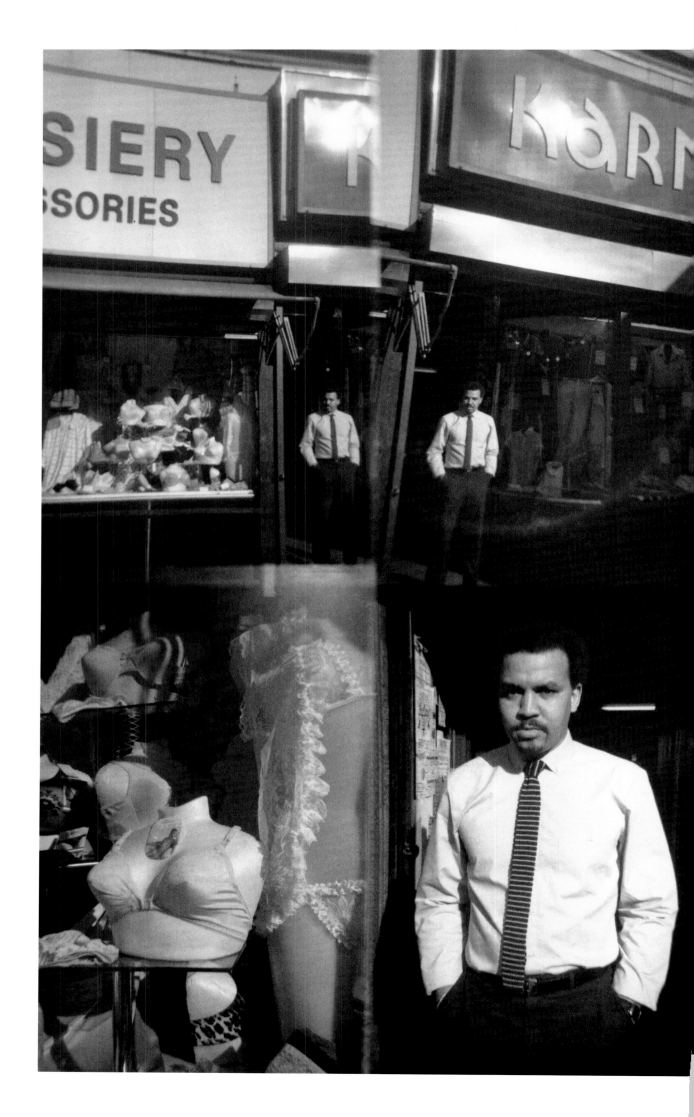

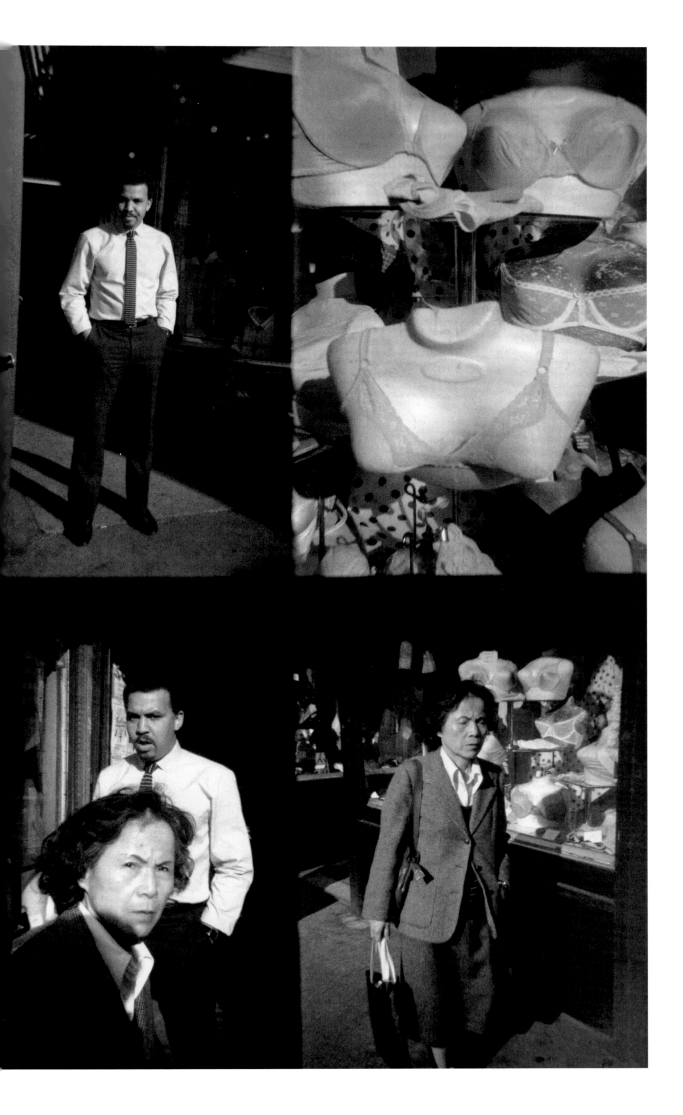

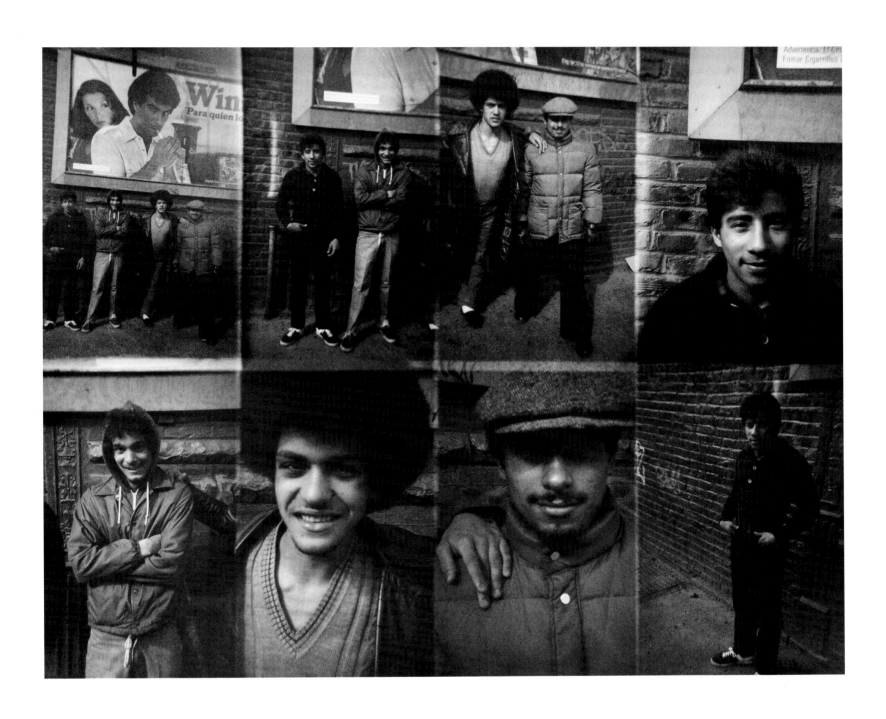

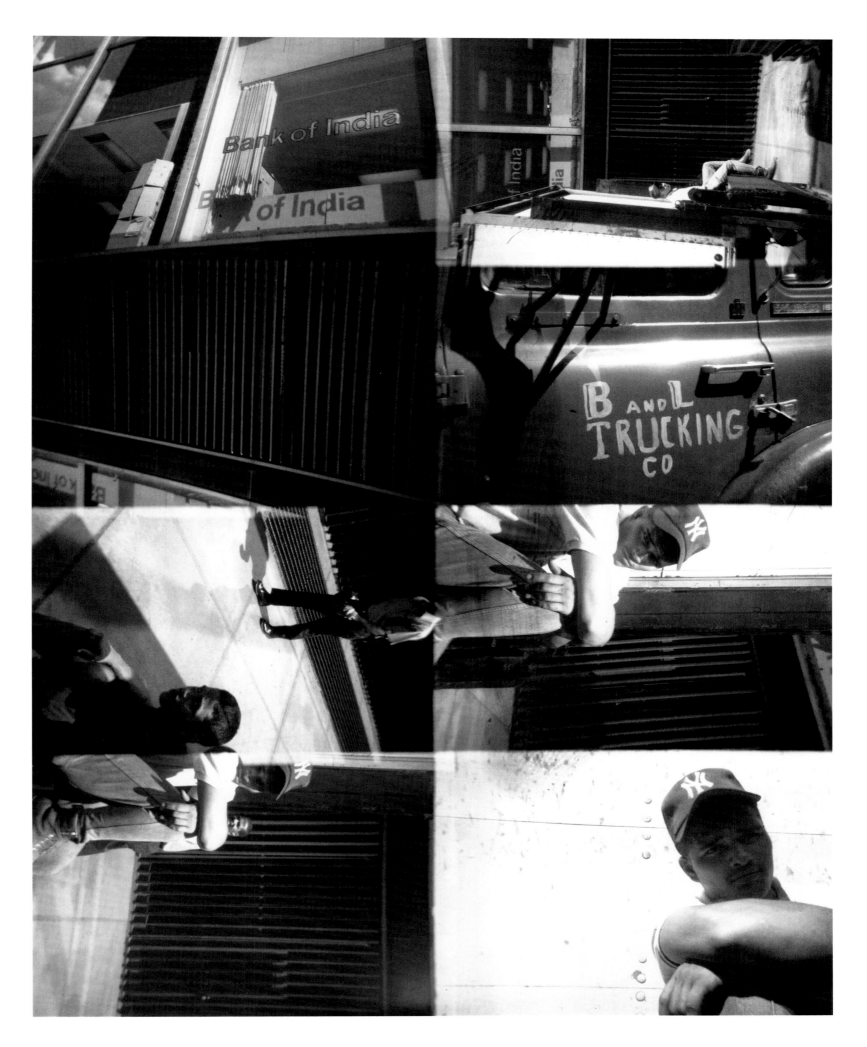

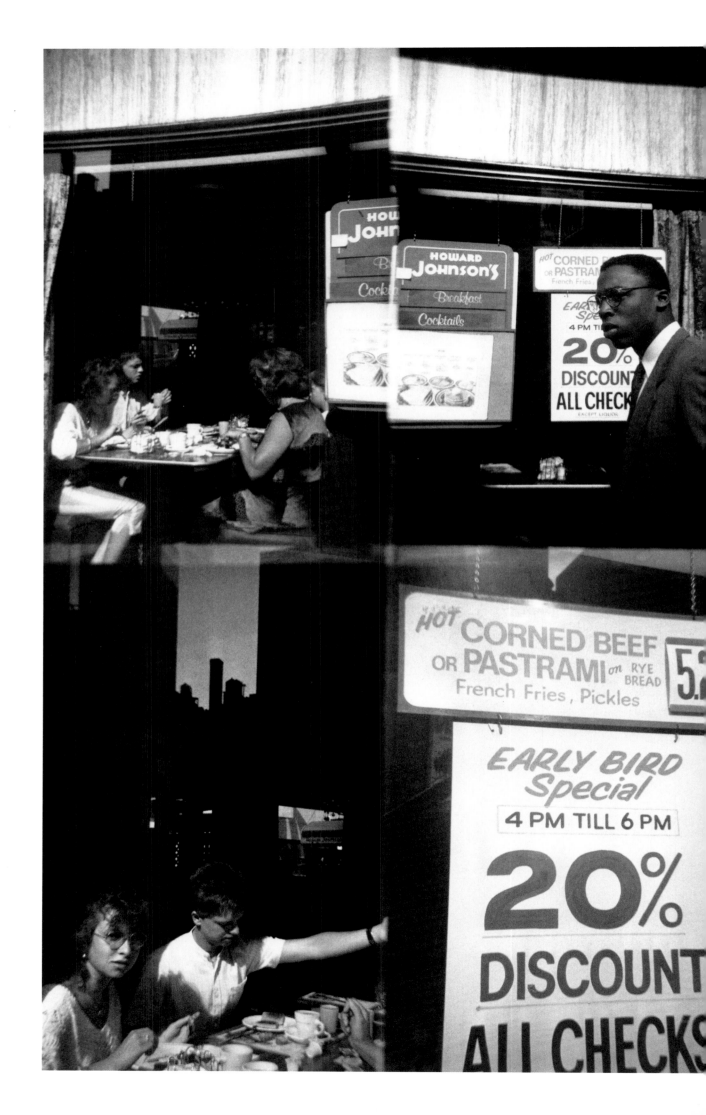

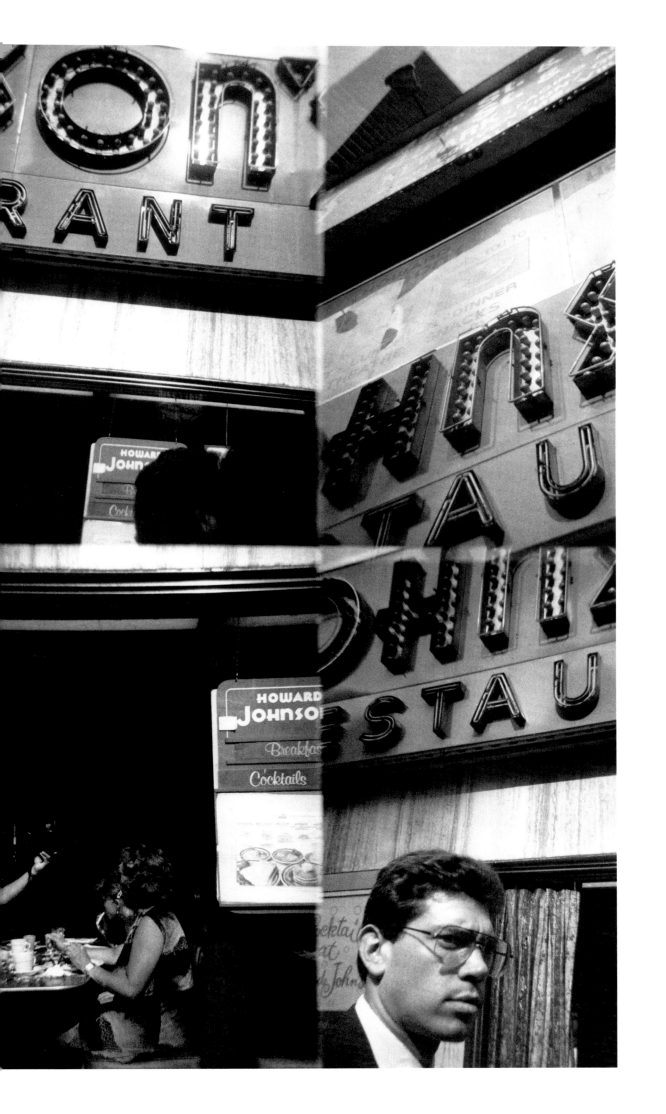

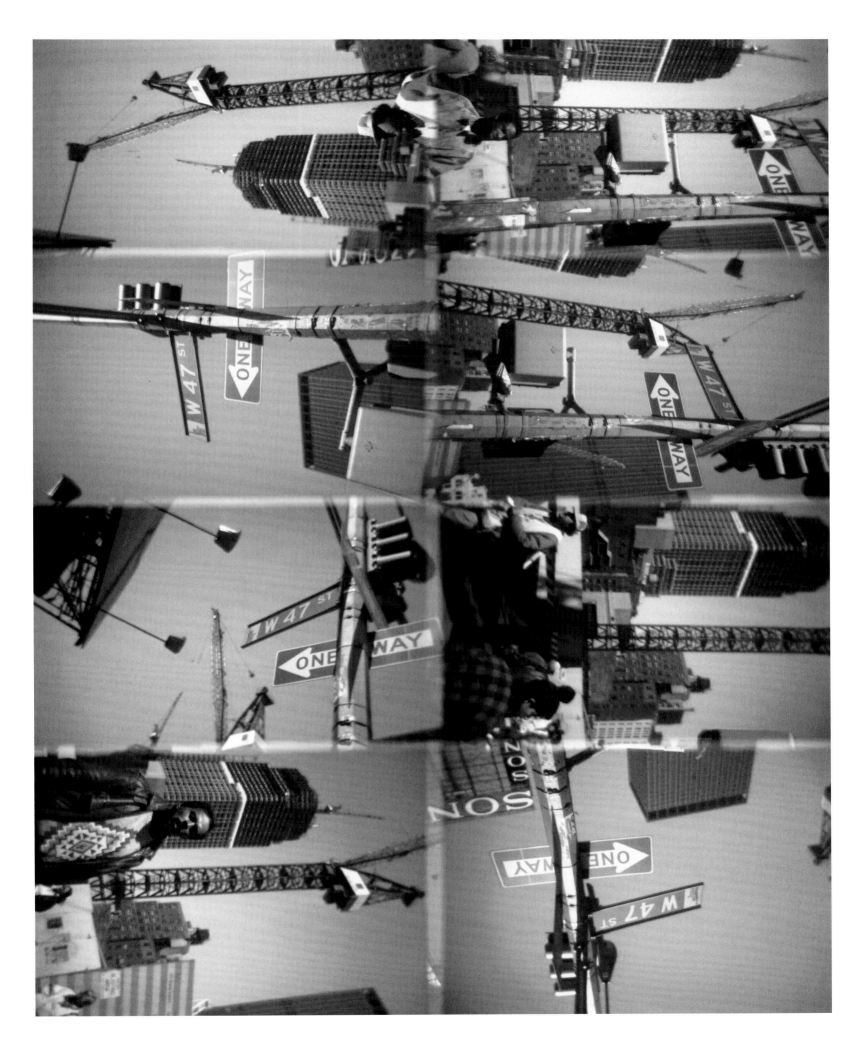

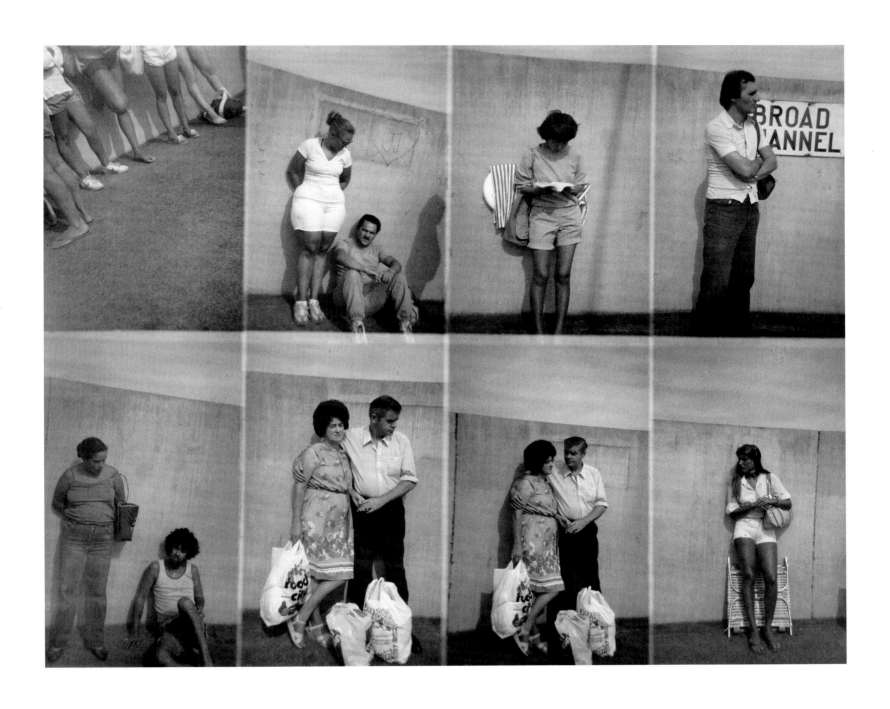

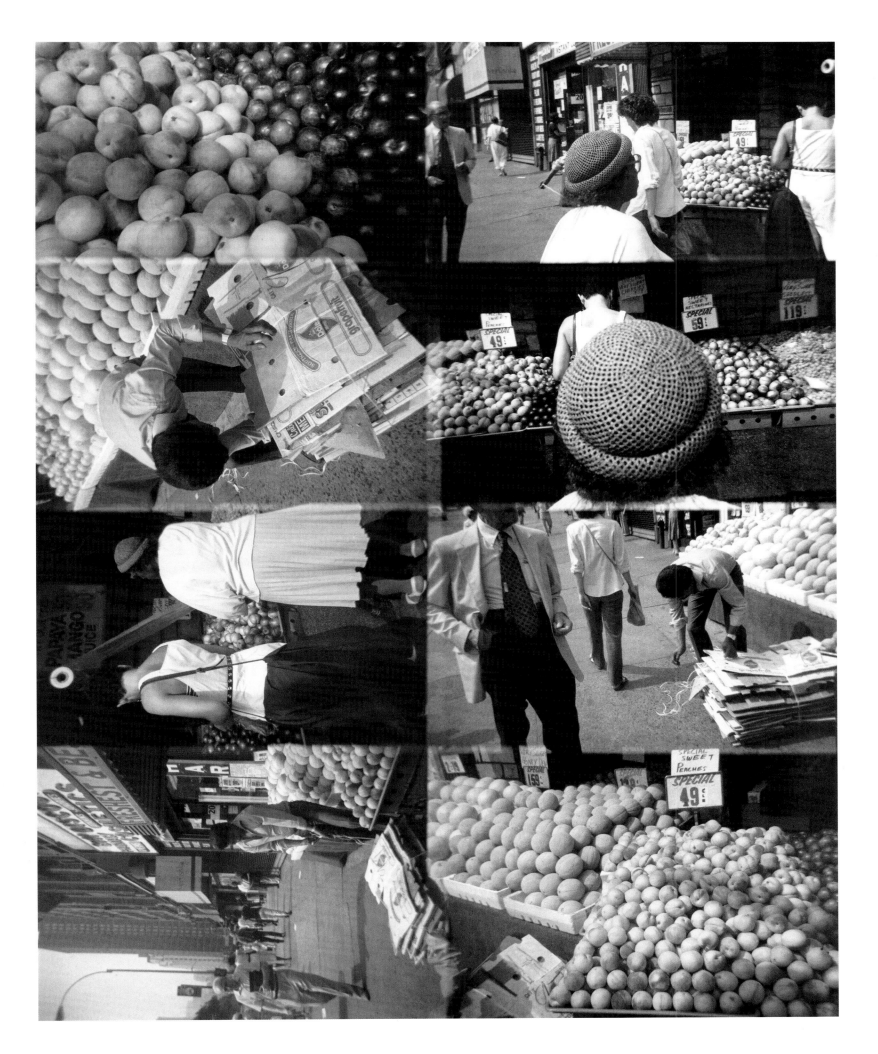

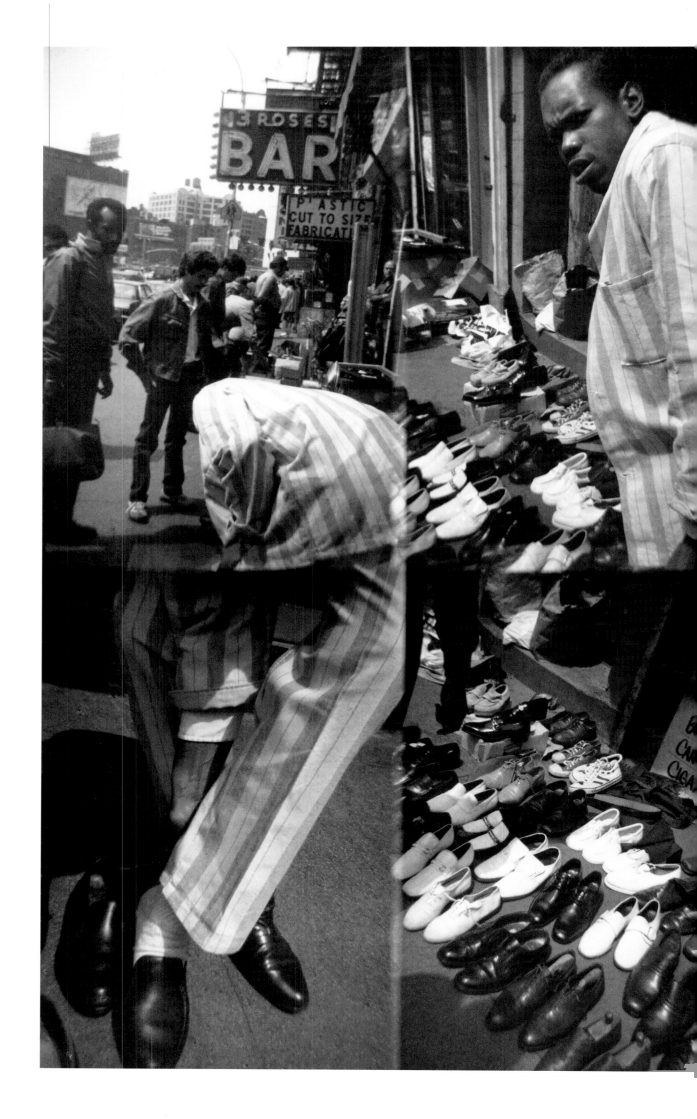

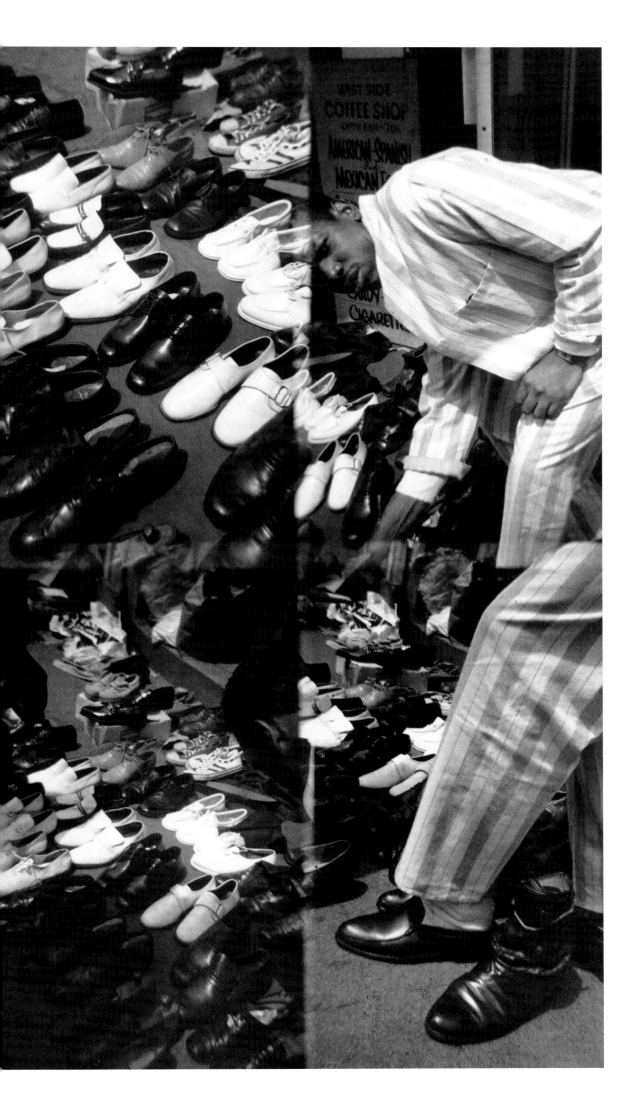

Portraits

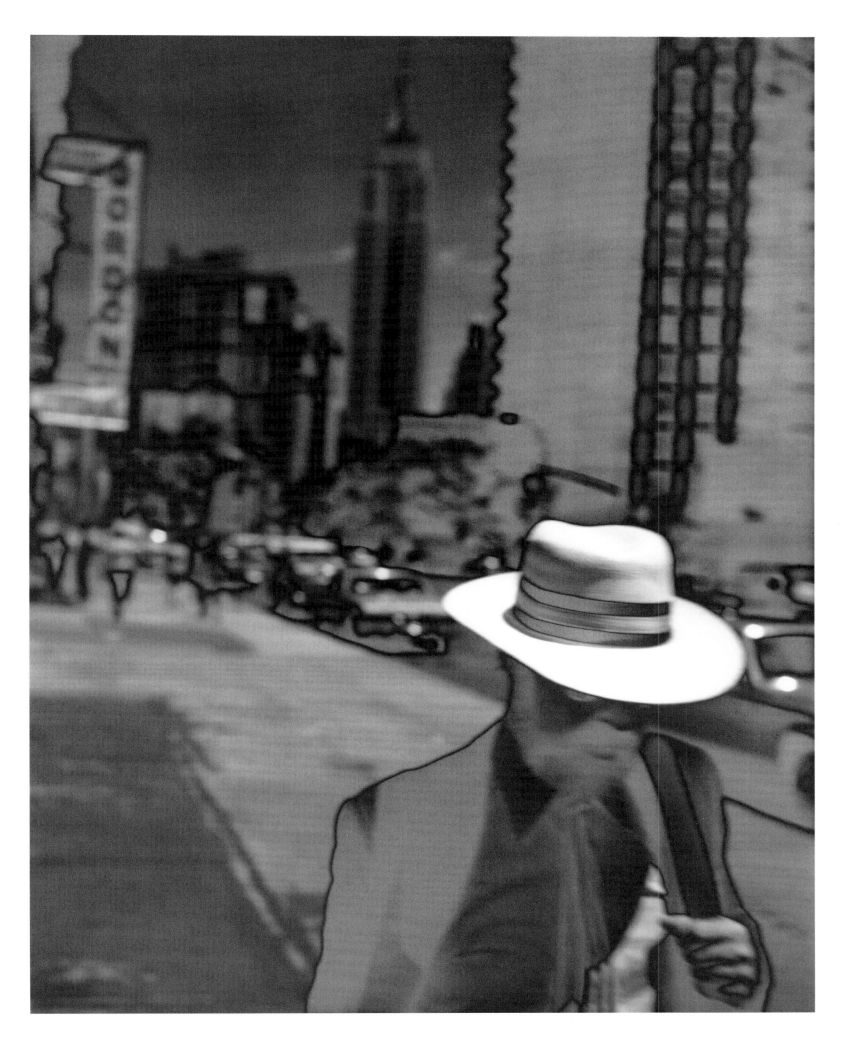

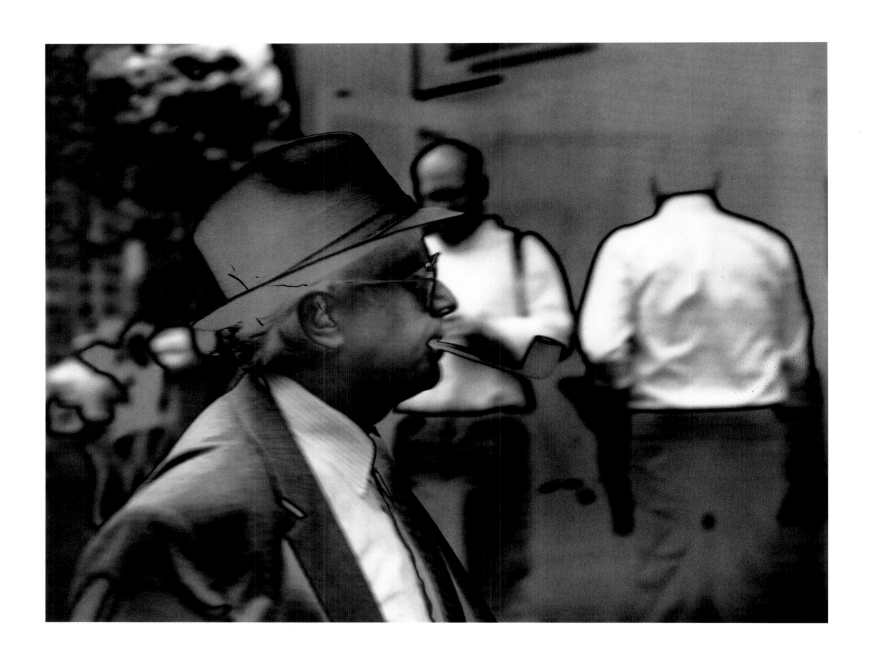

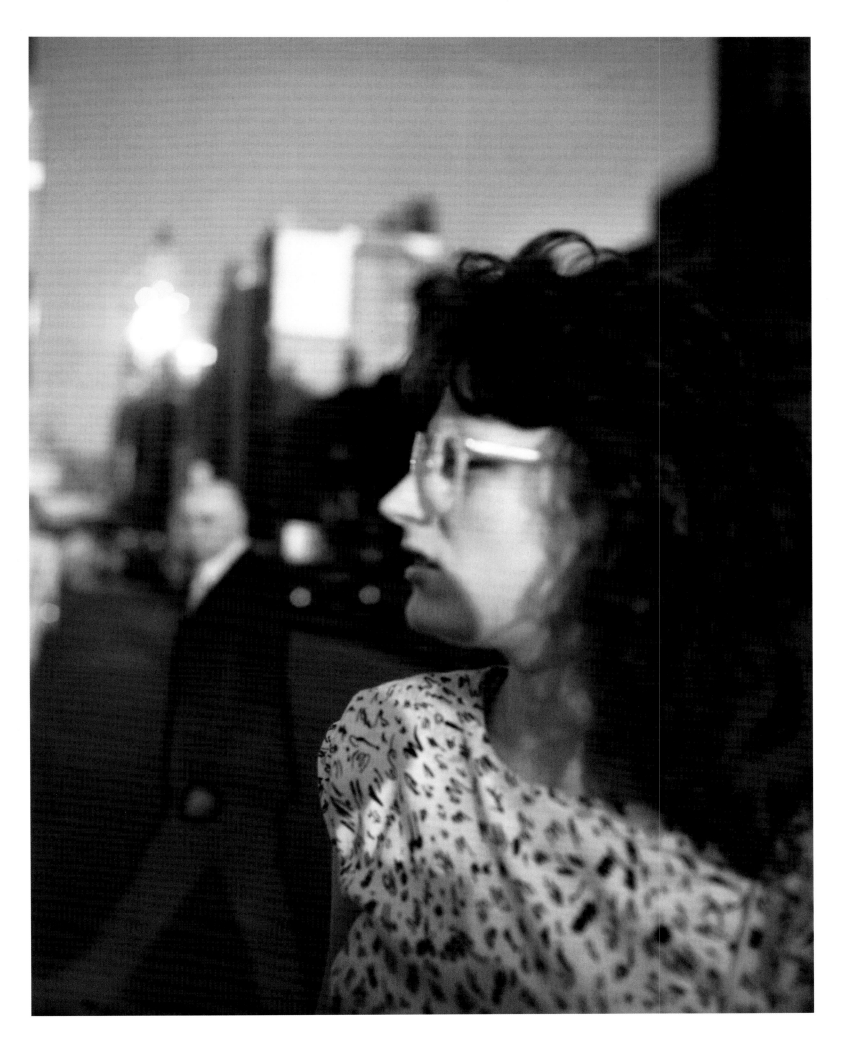

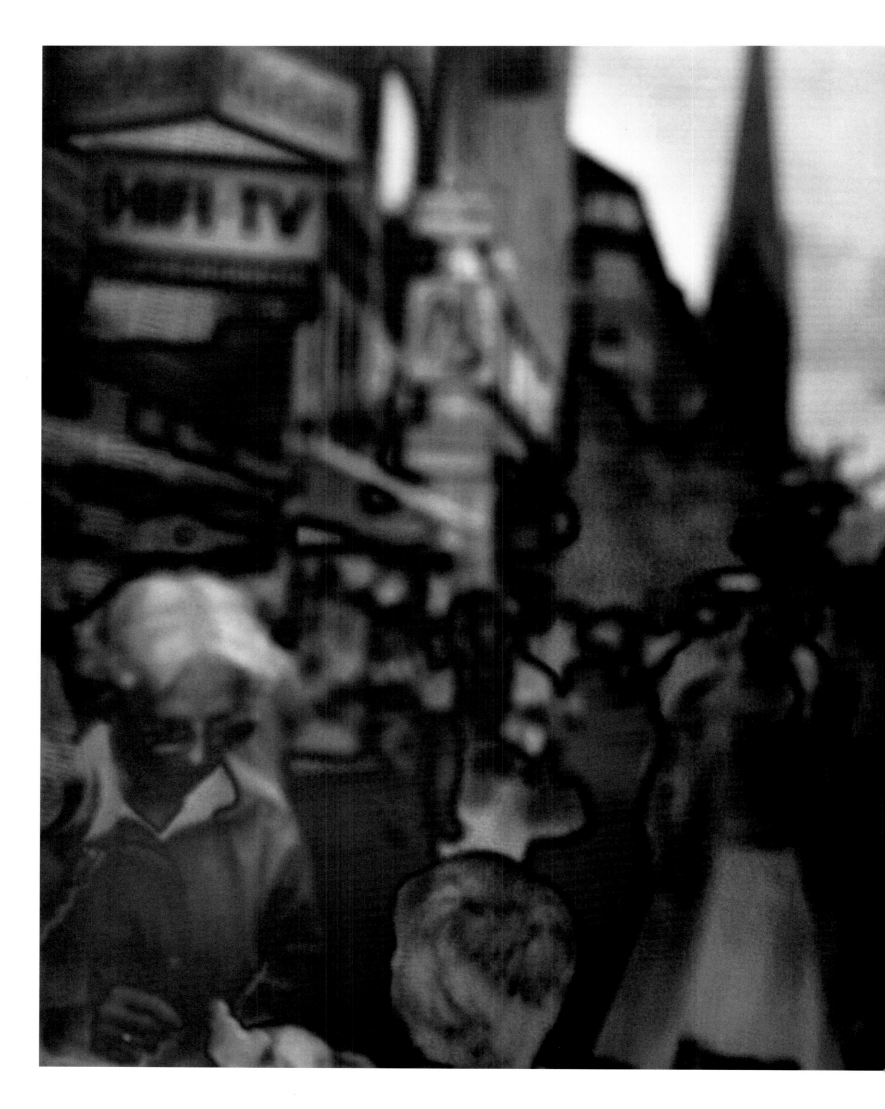

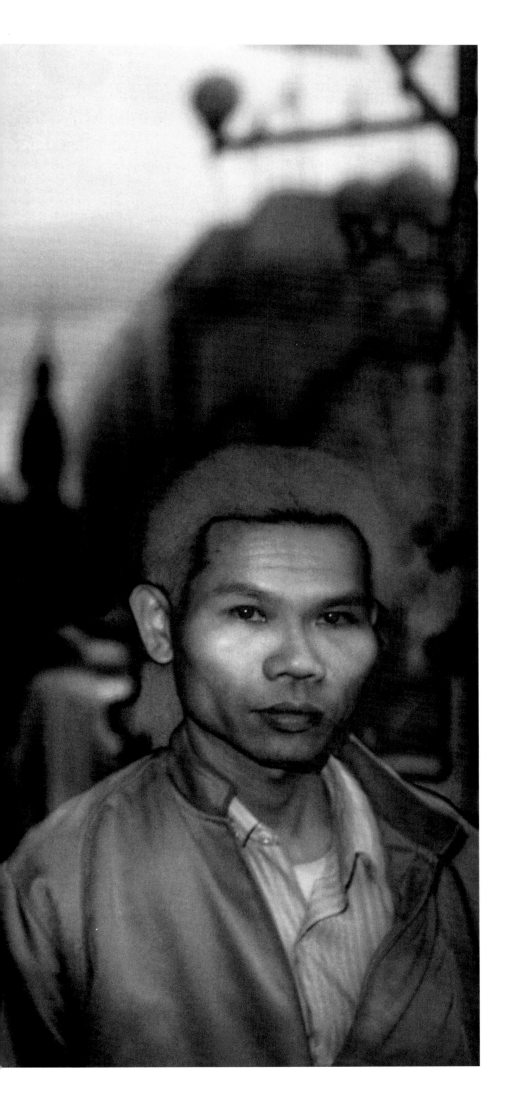

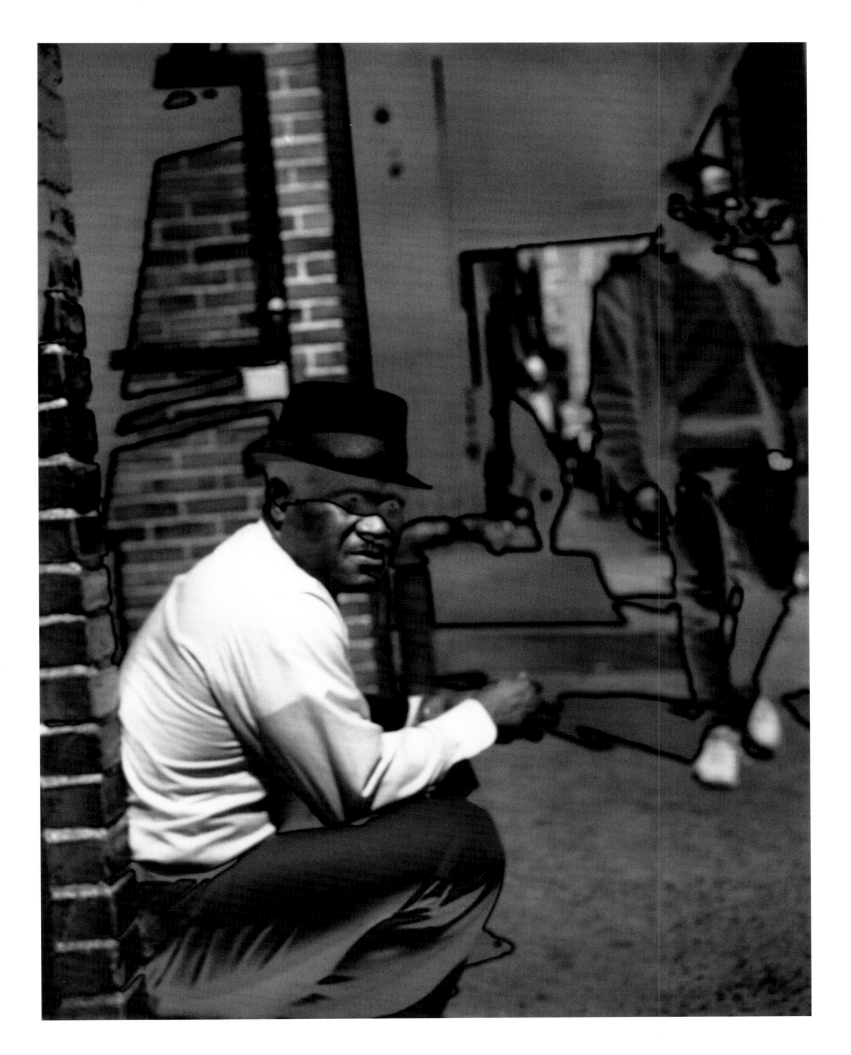

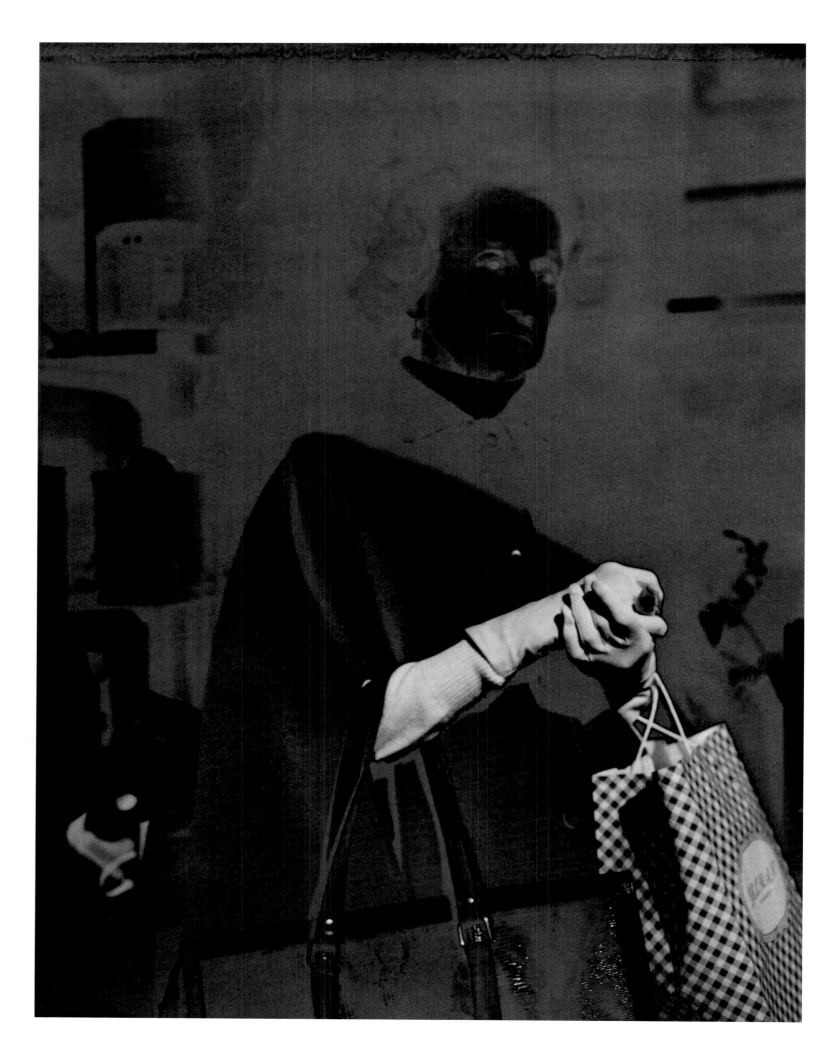

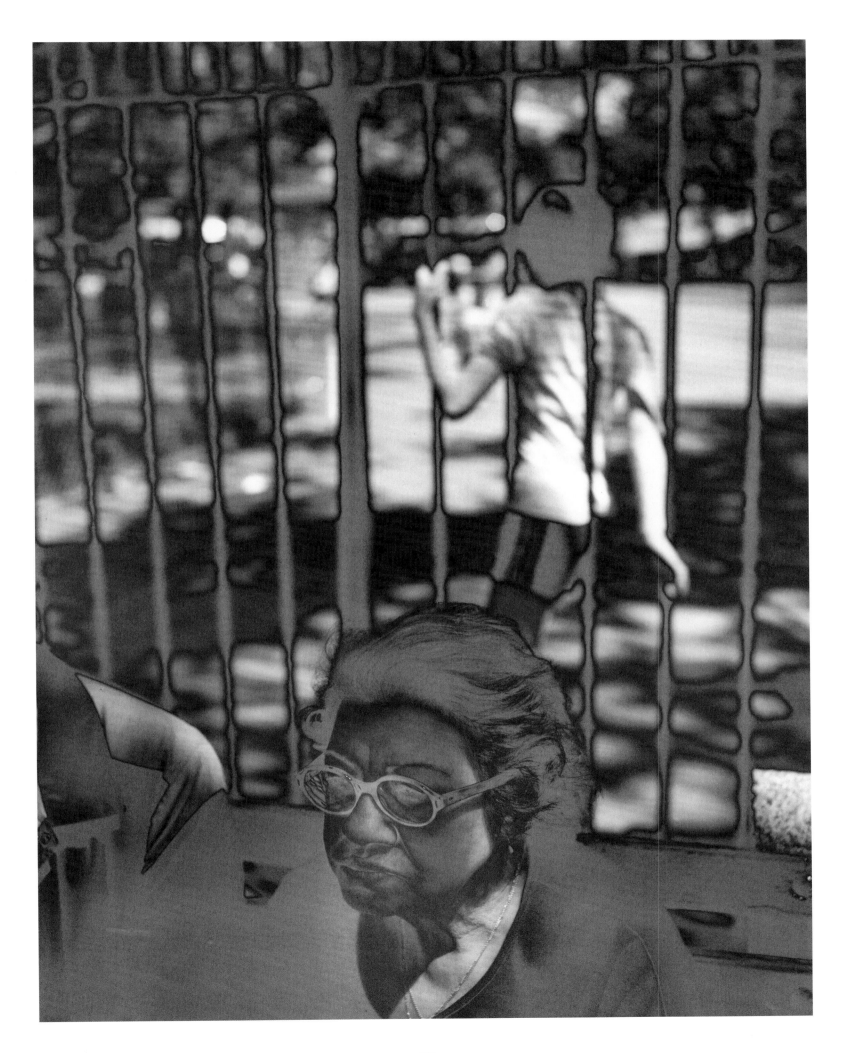

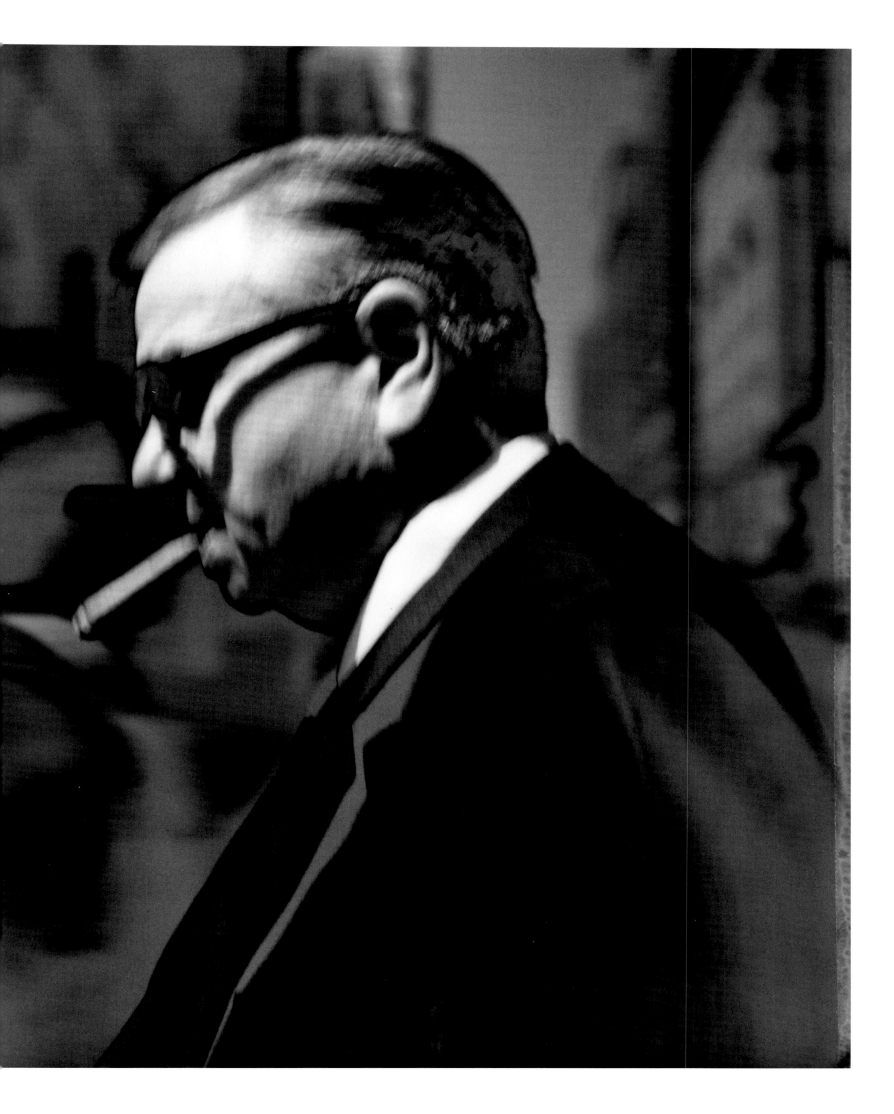

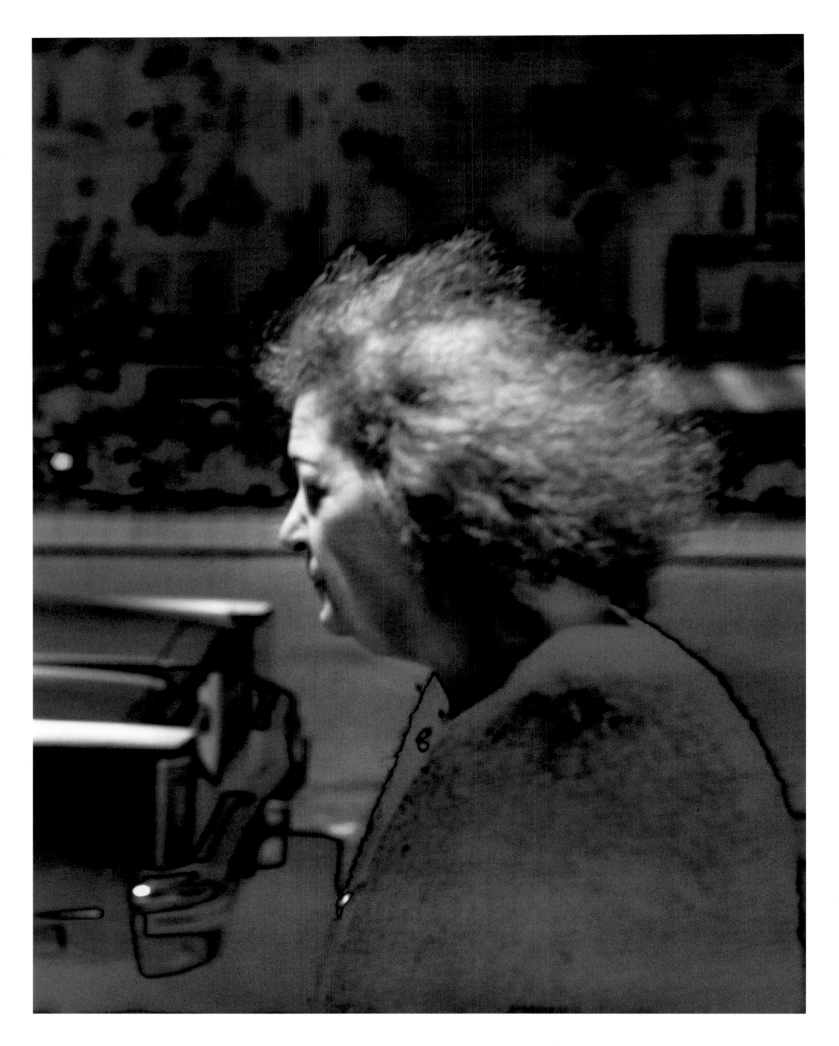

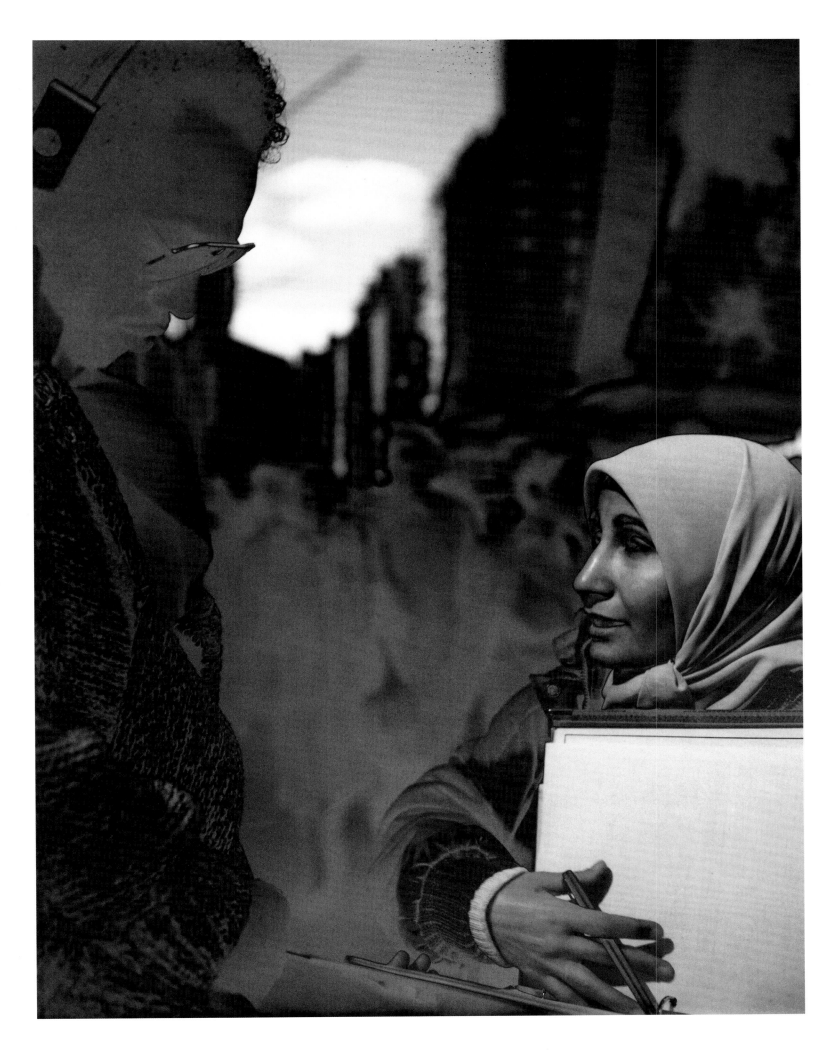

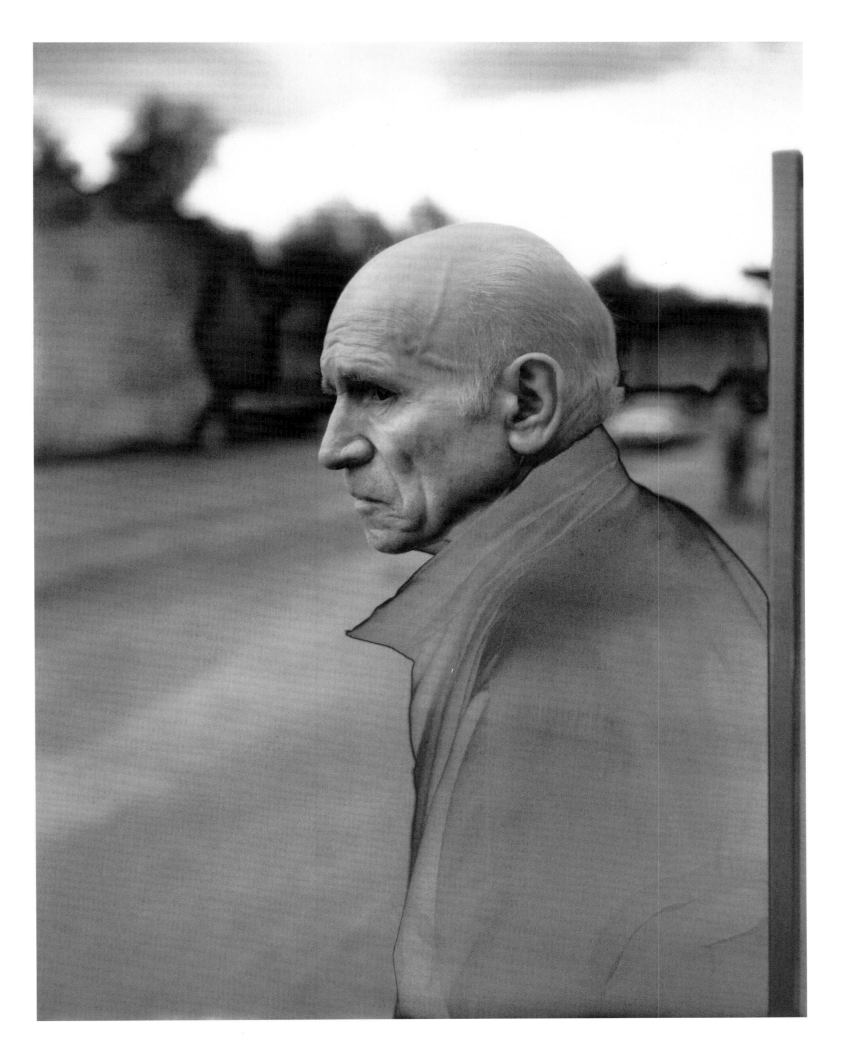

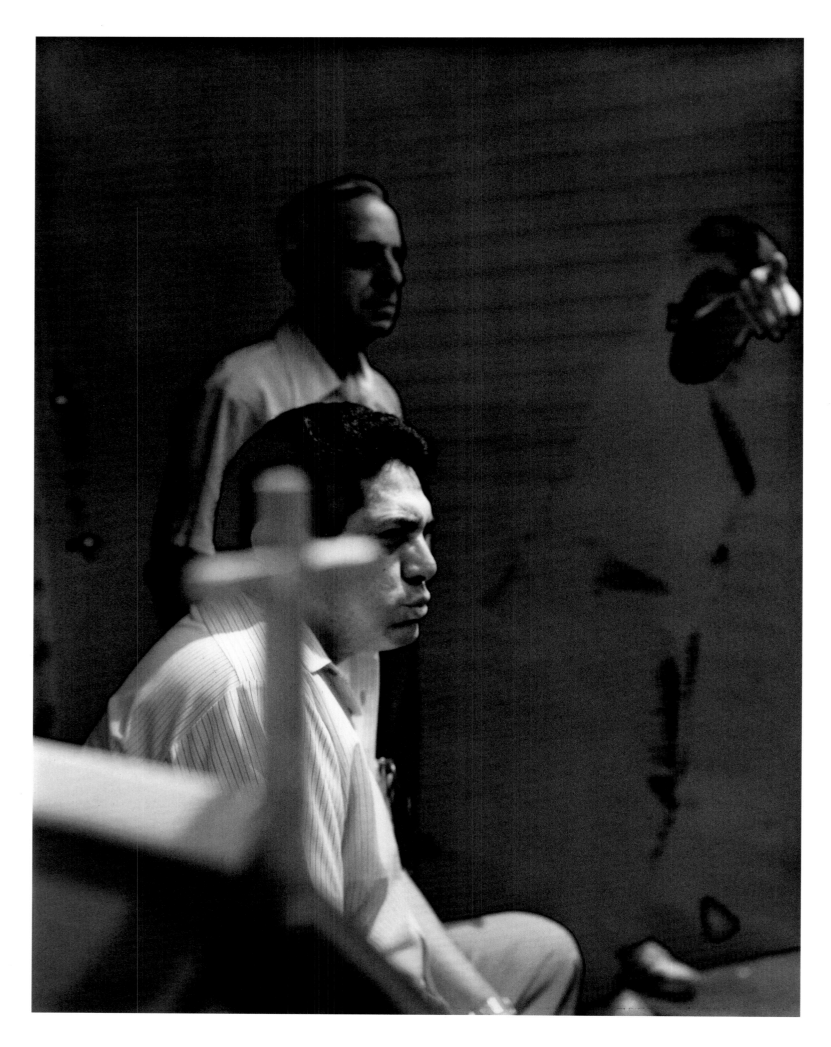

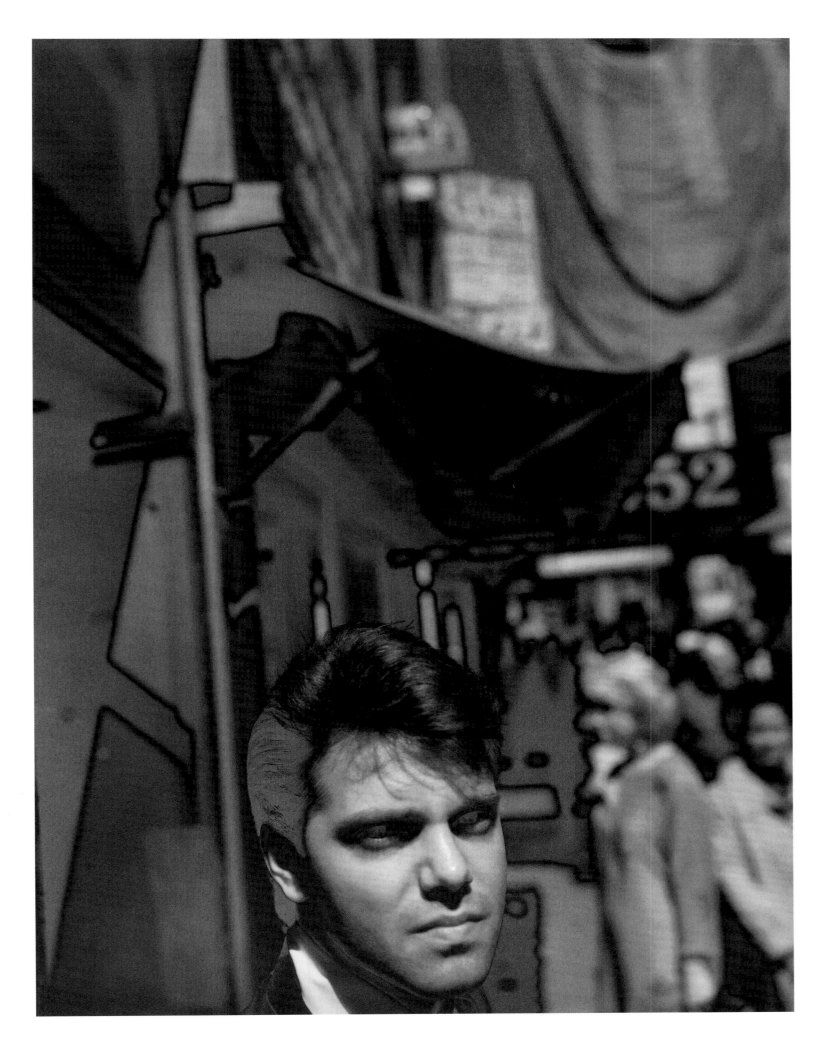

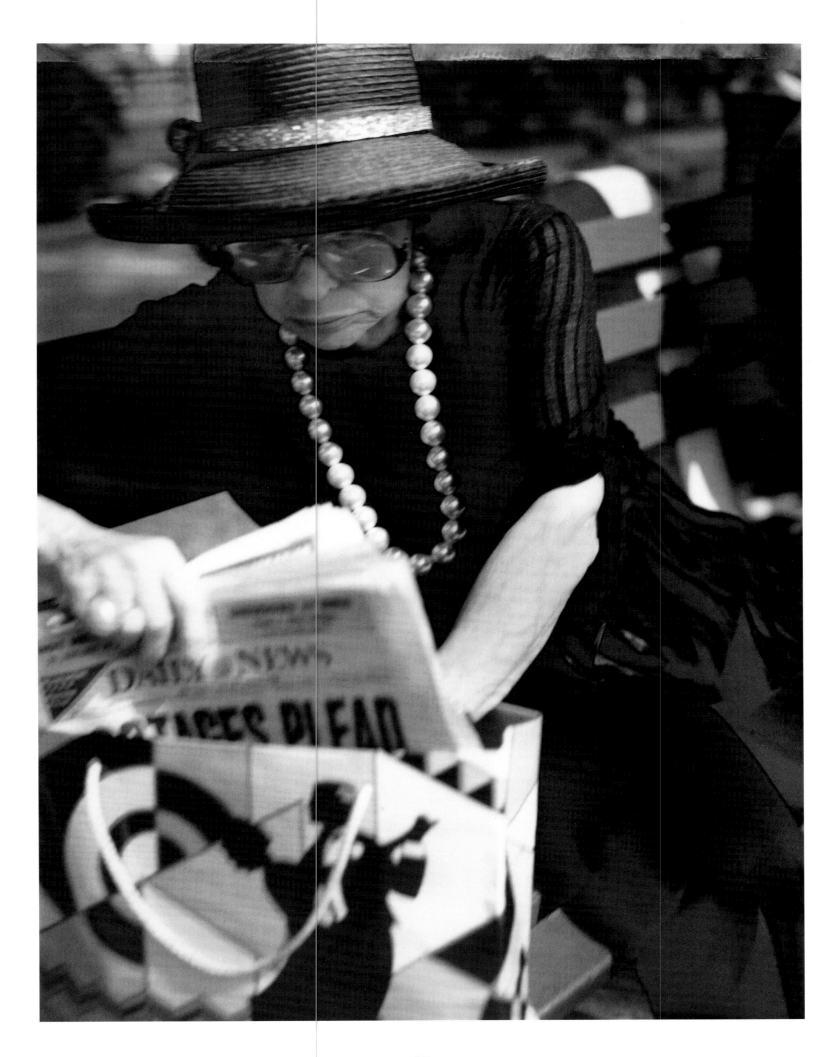

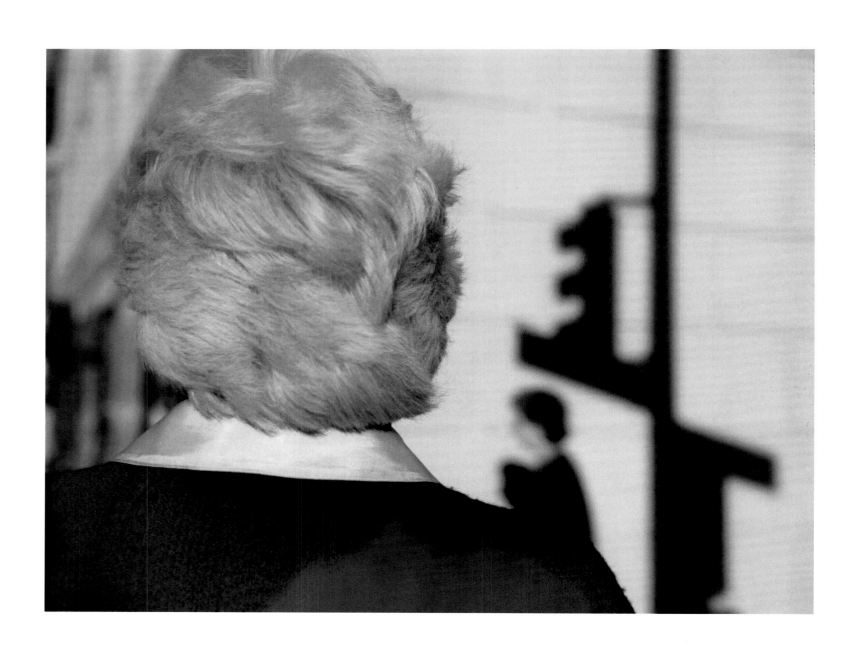

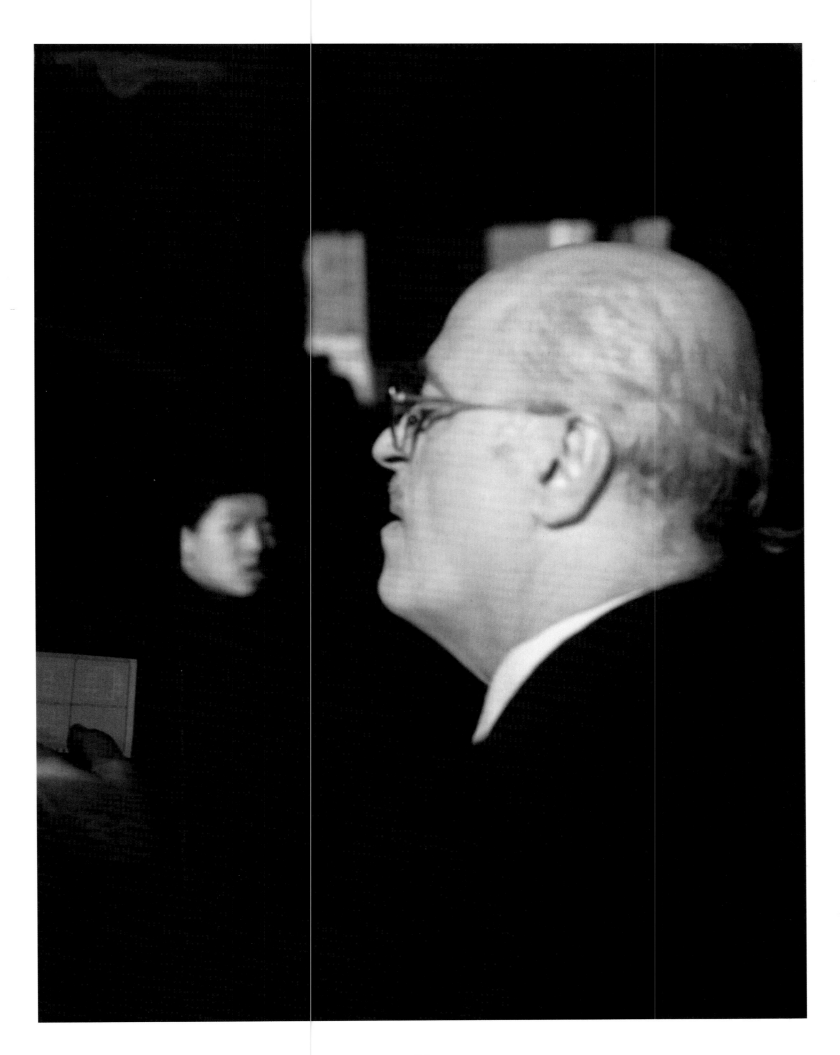

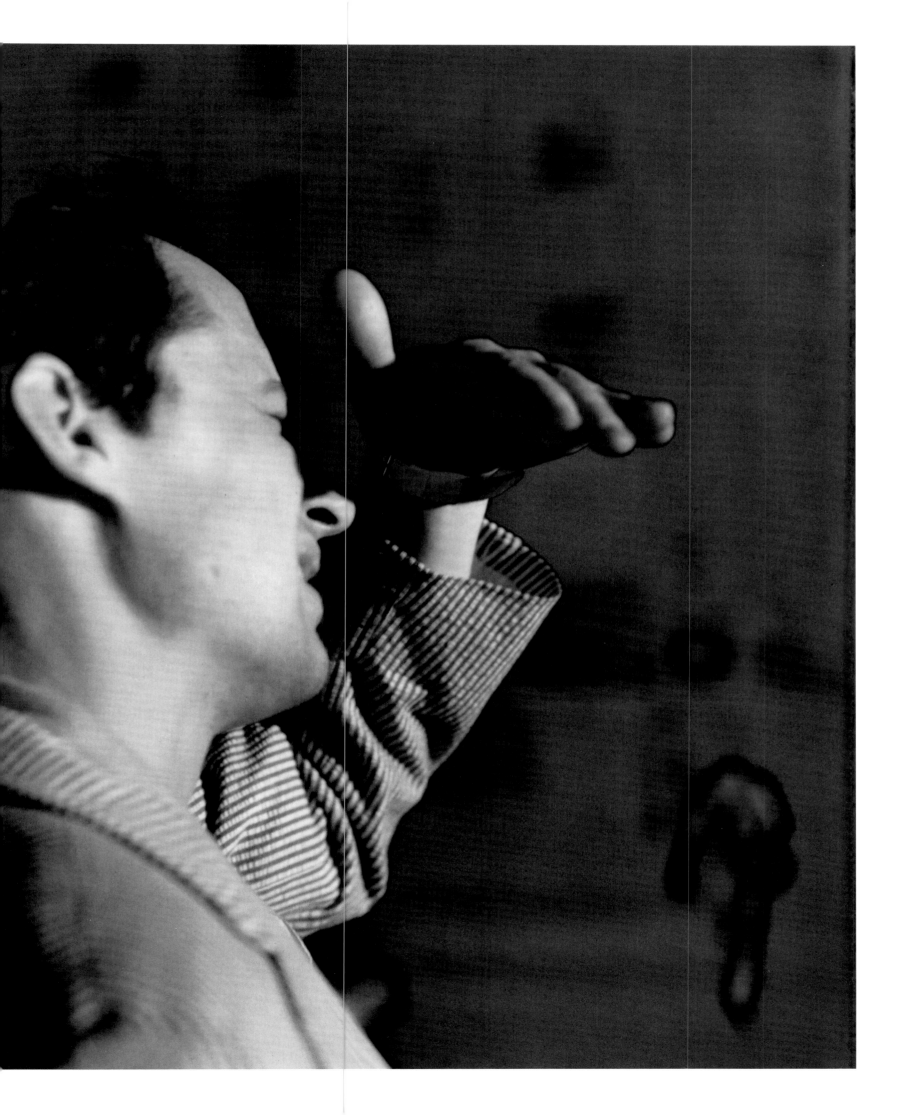

Multi-Exposures

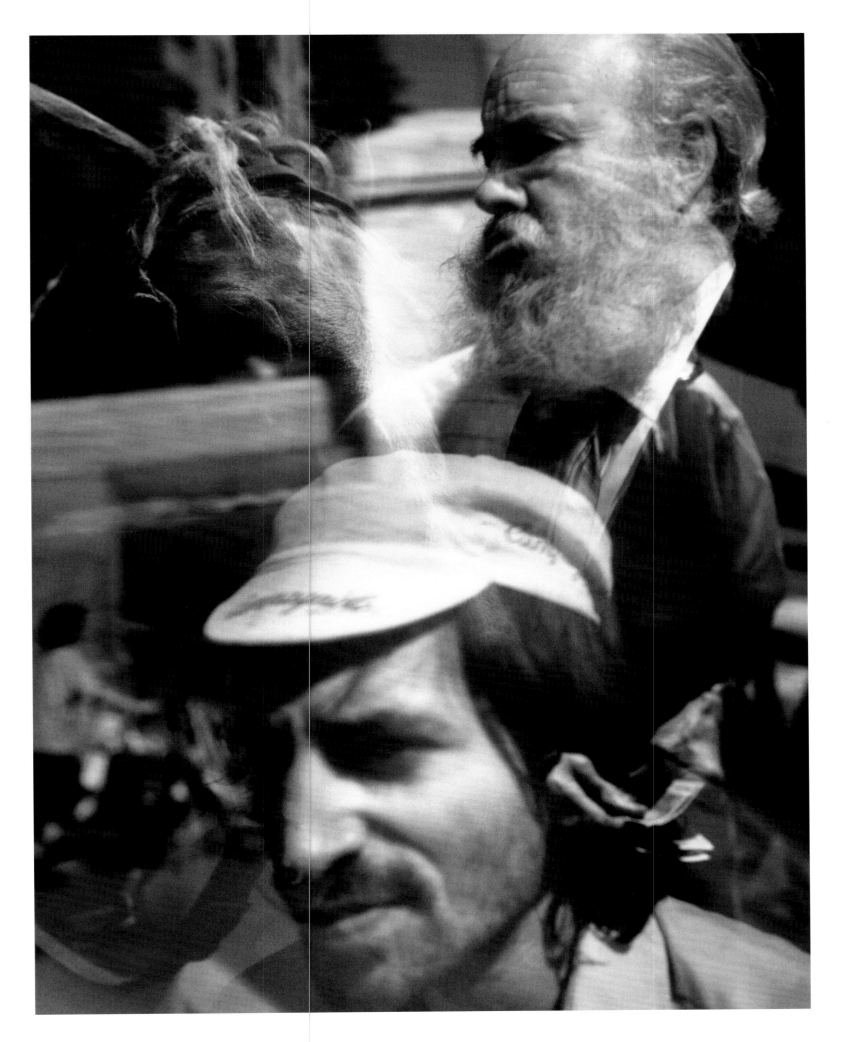

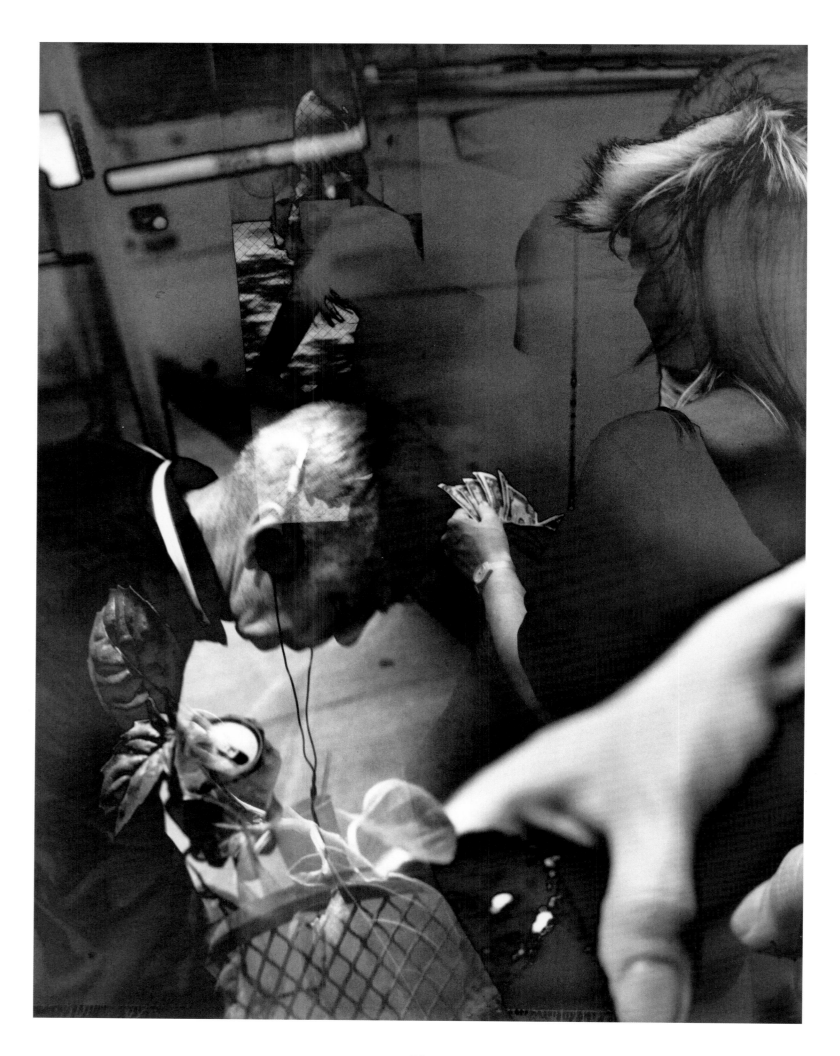

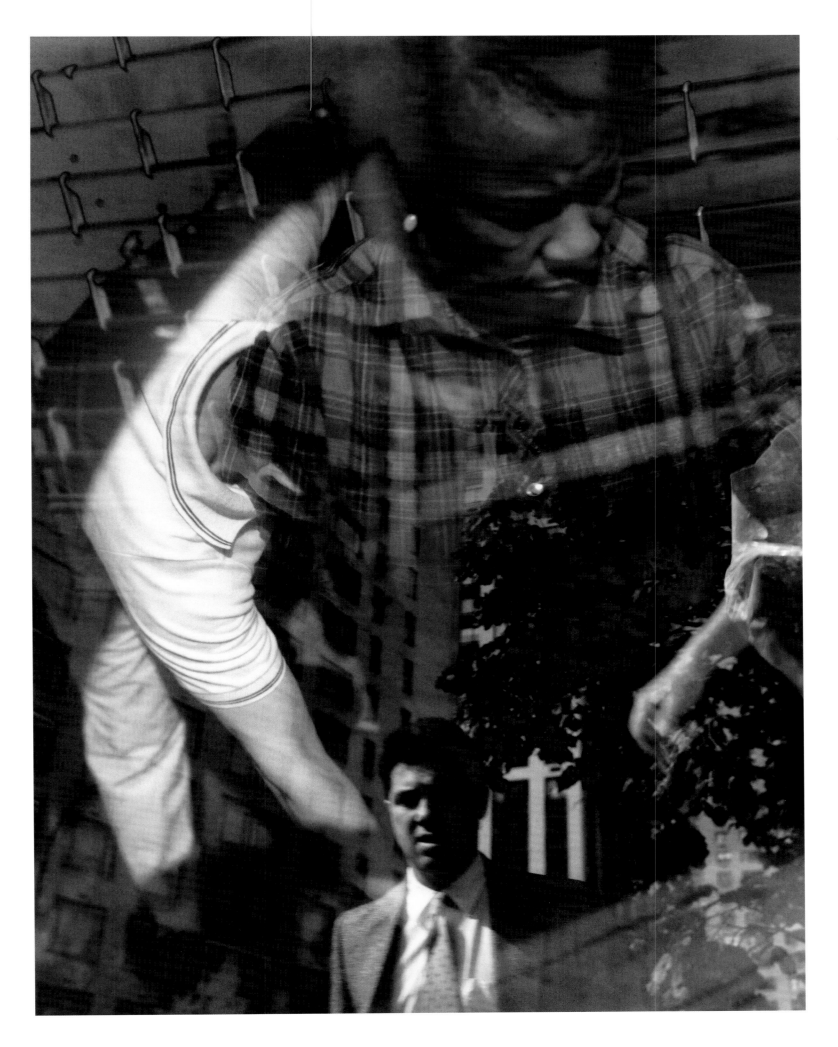

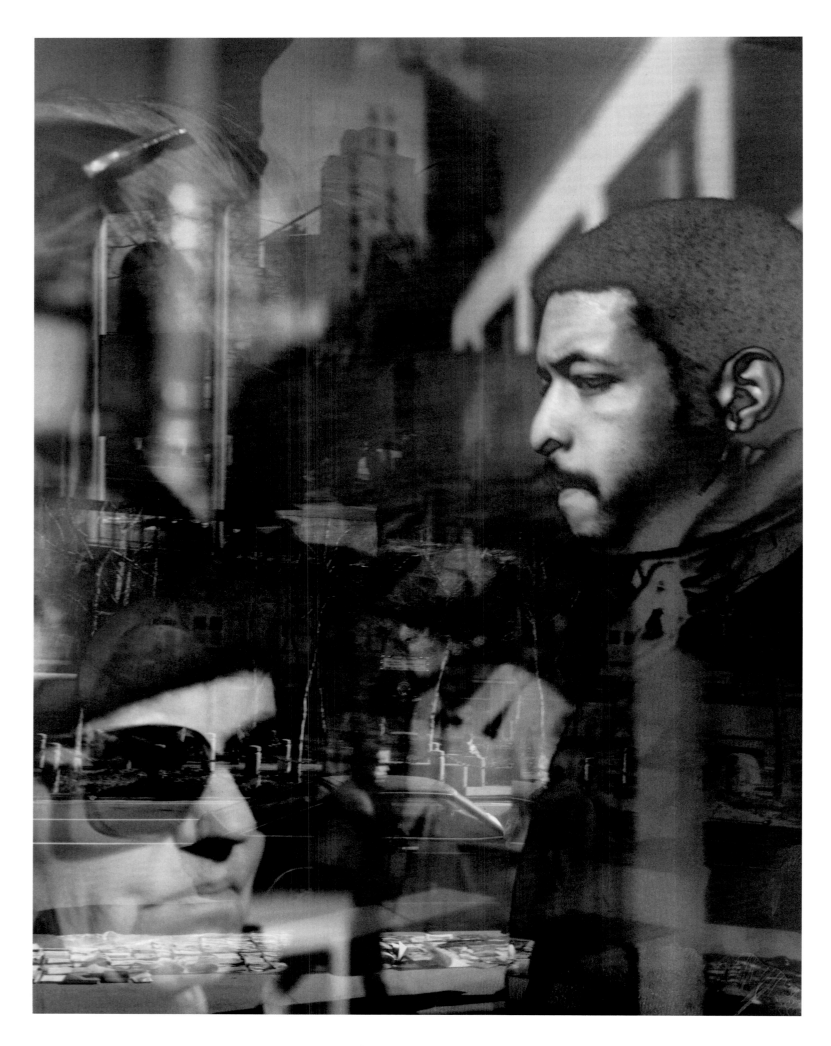

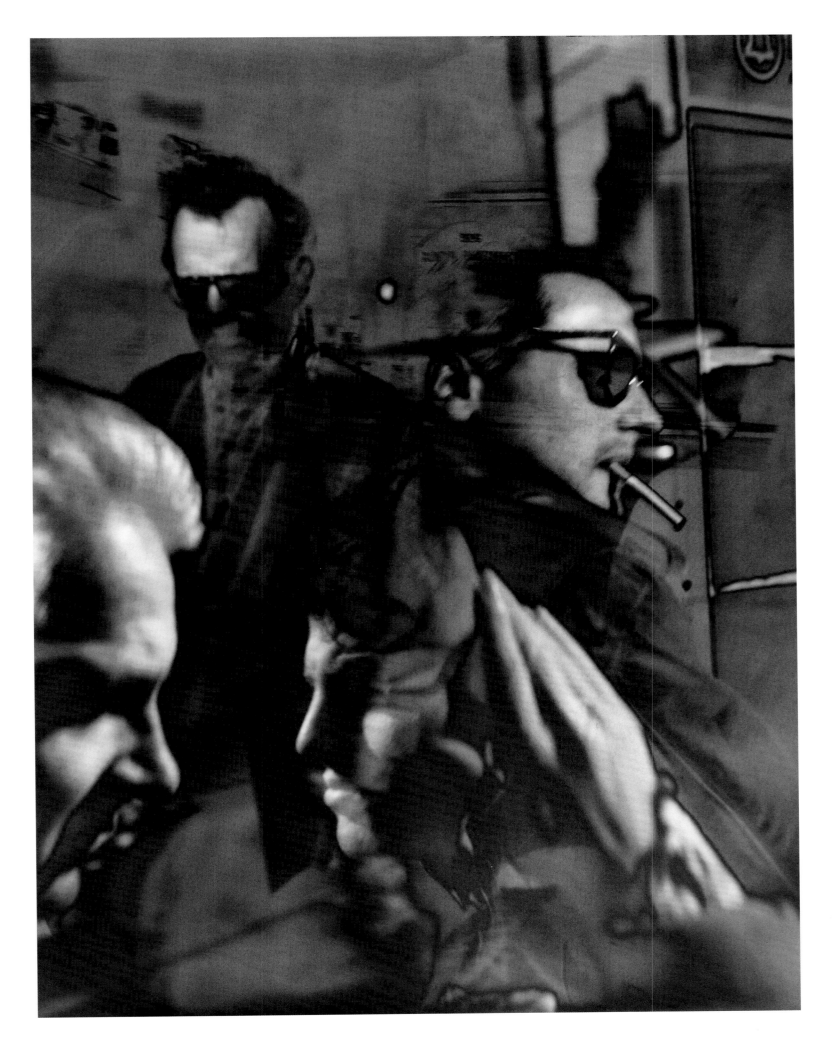

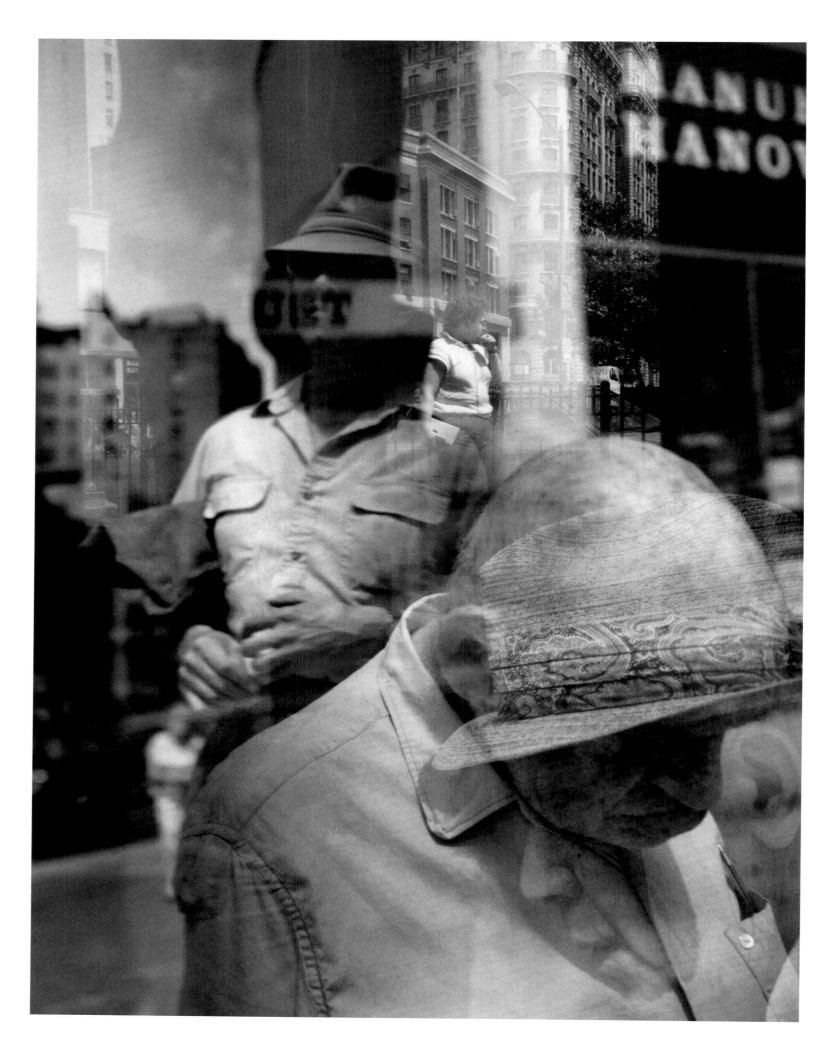

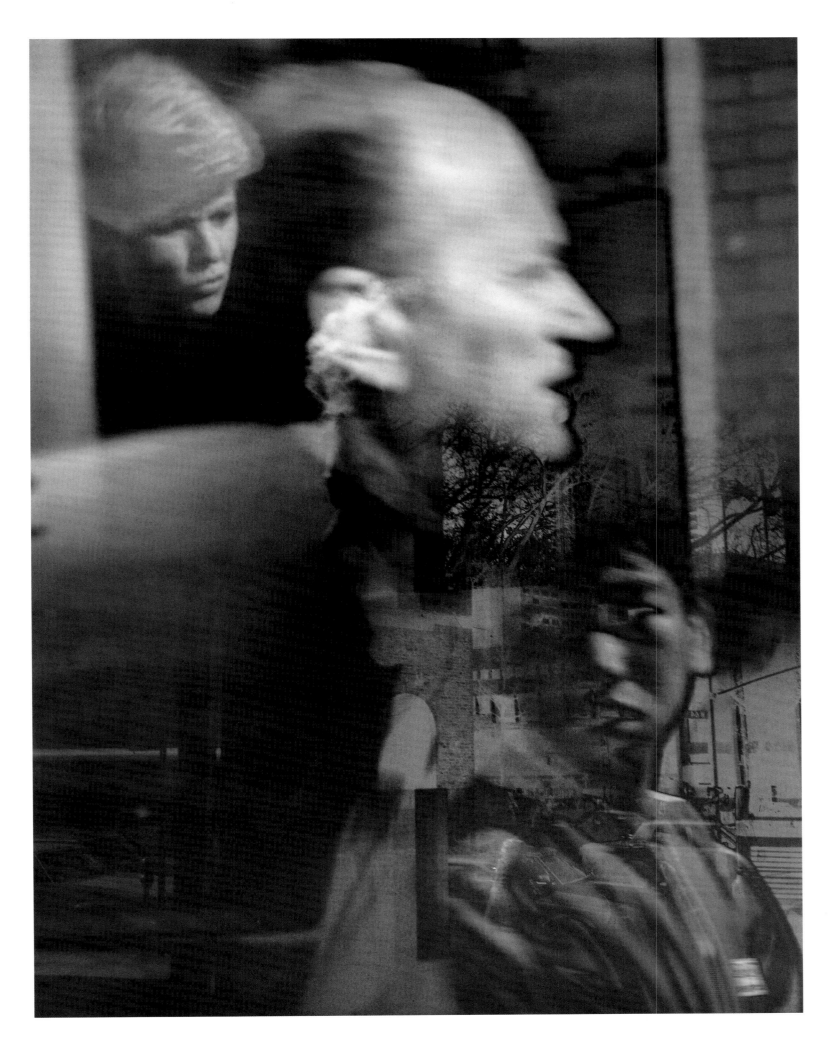

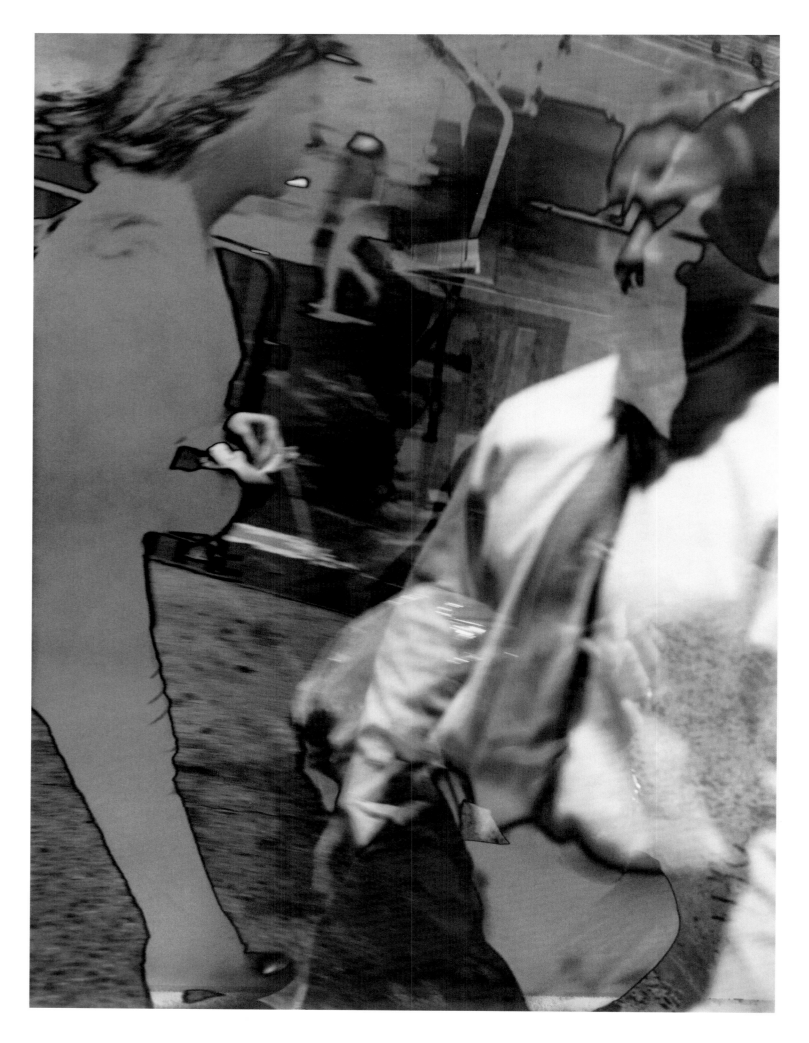

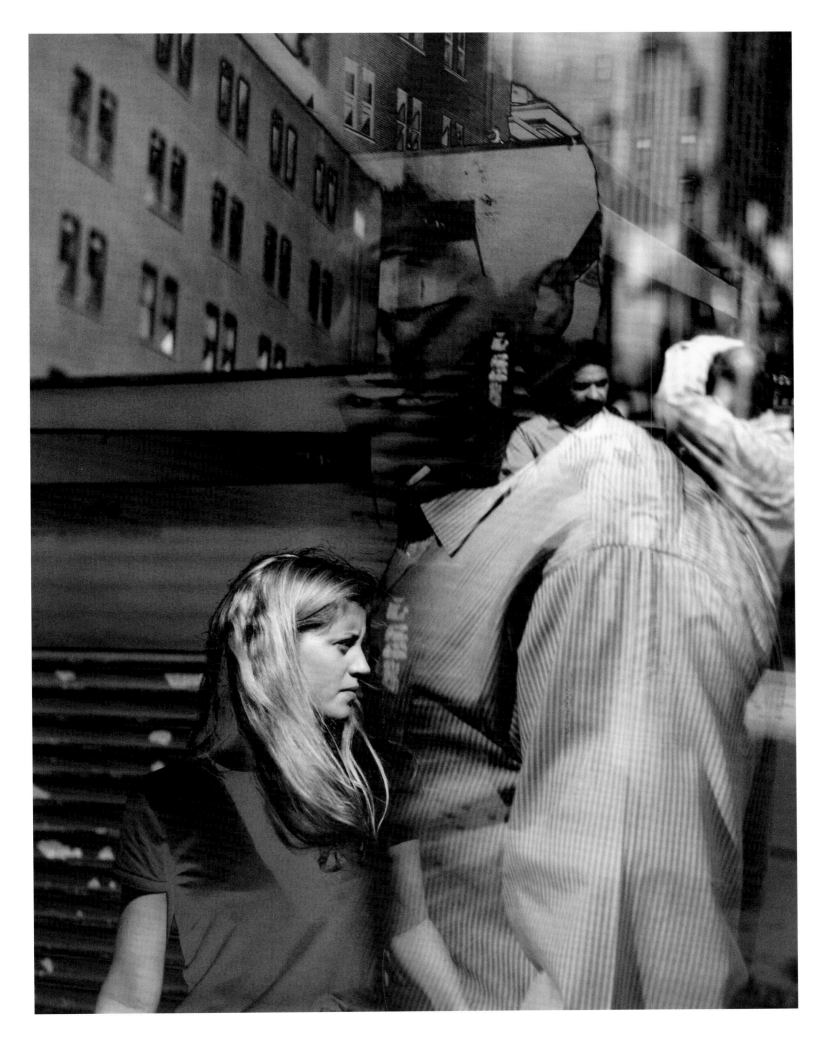

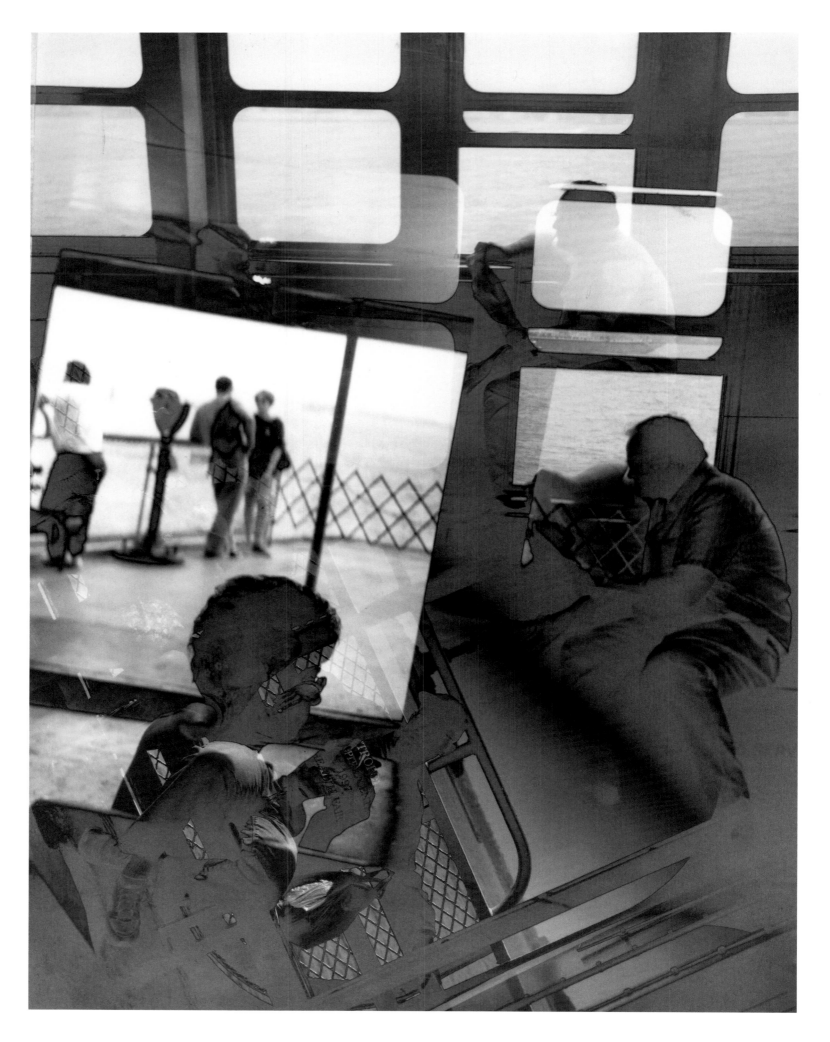

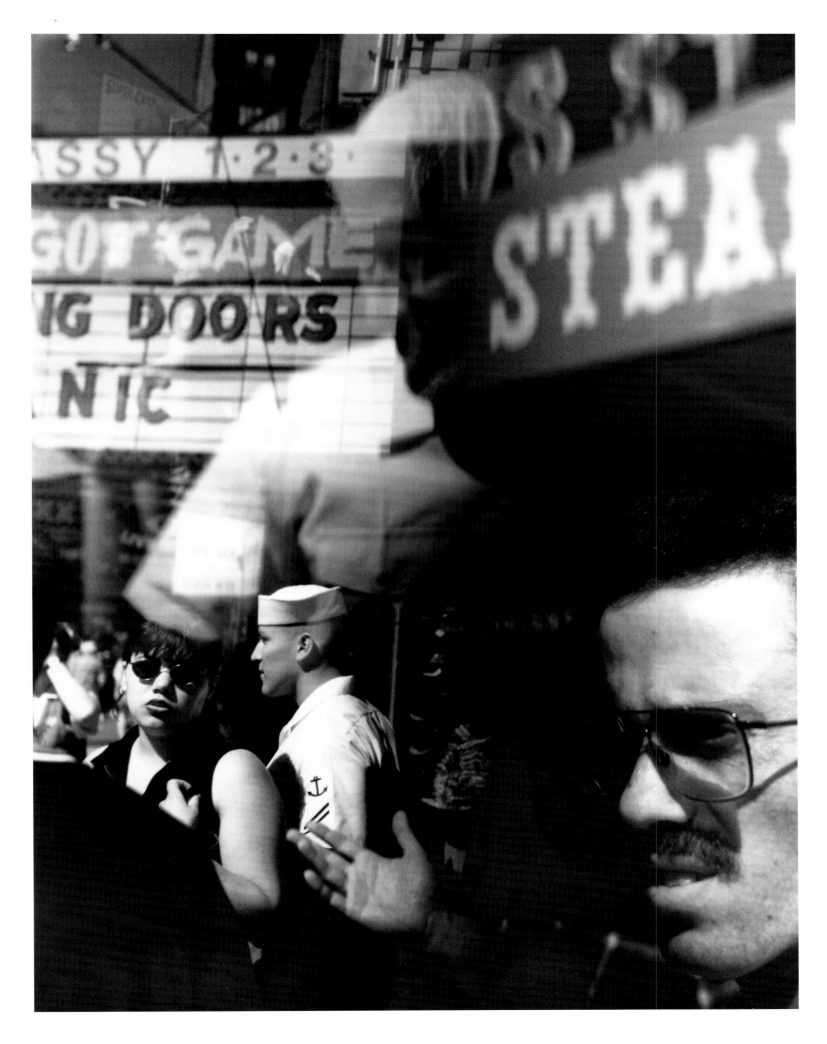

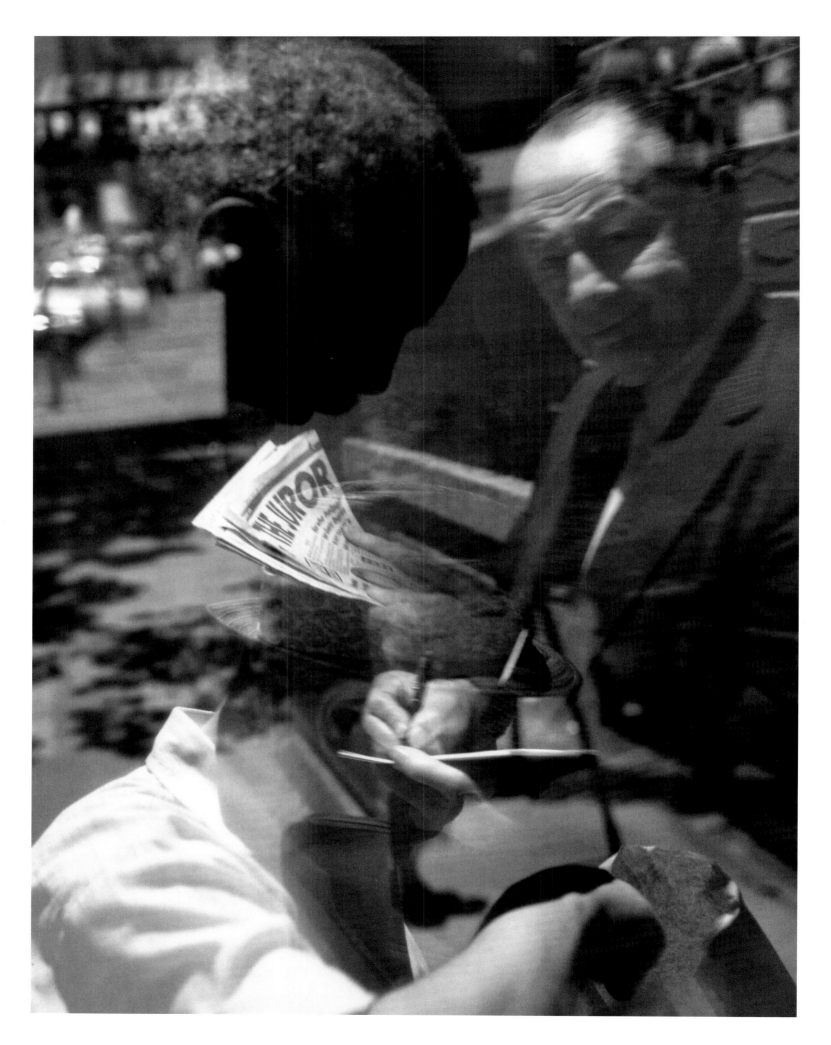

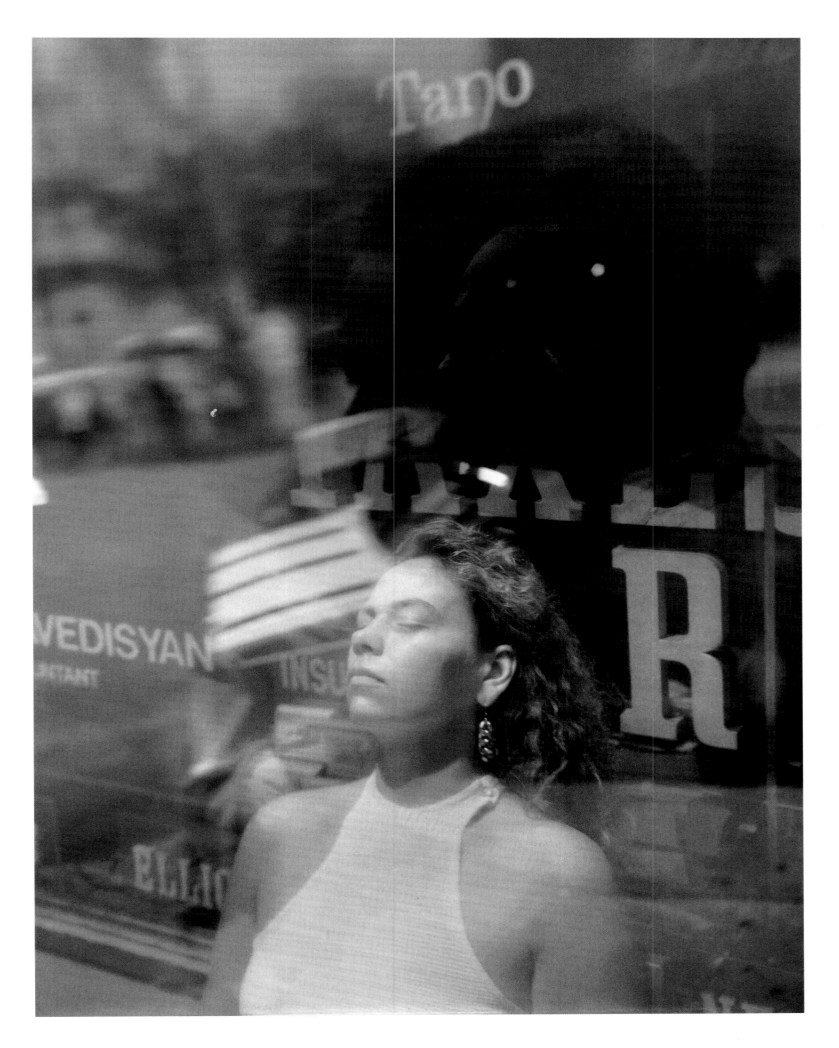

Diptychs

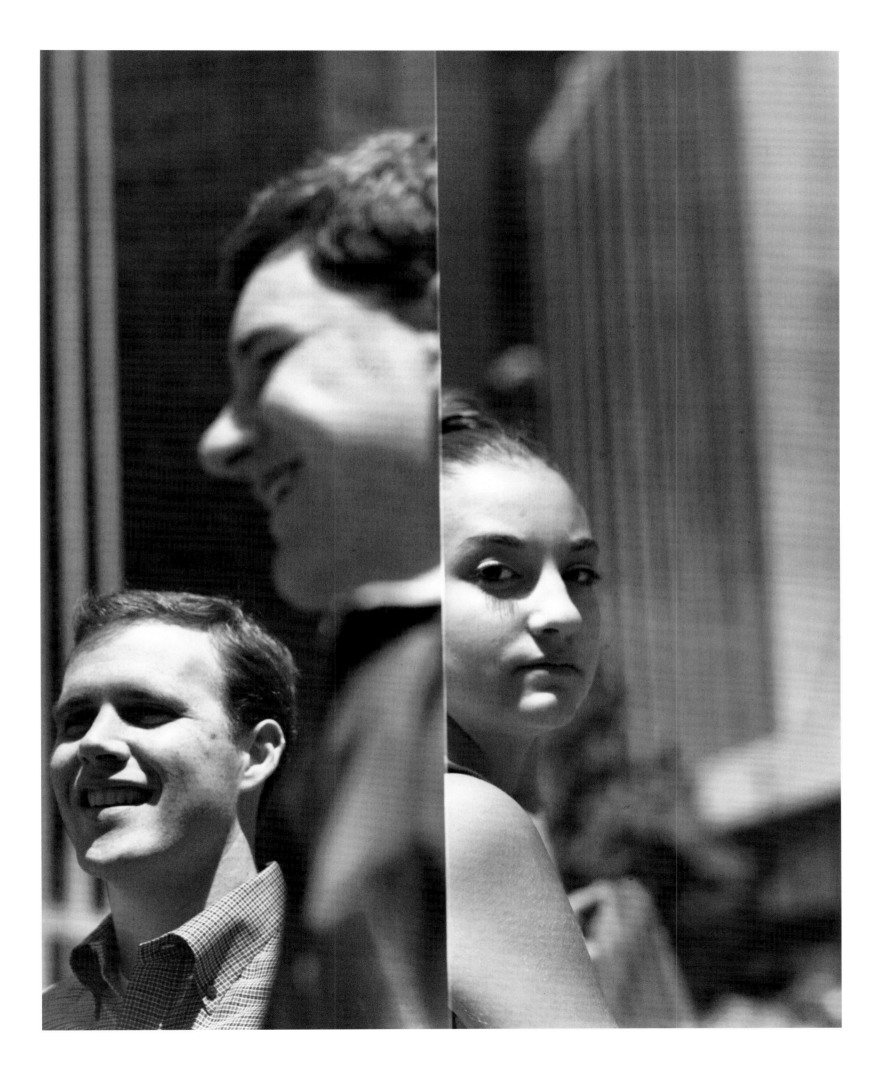

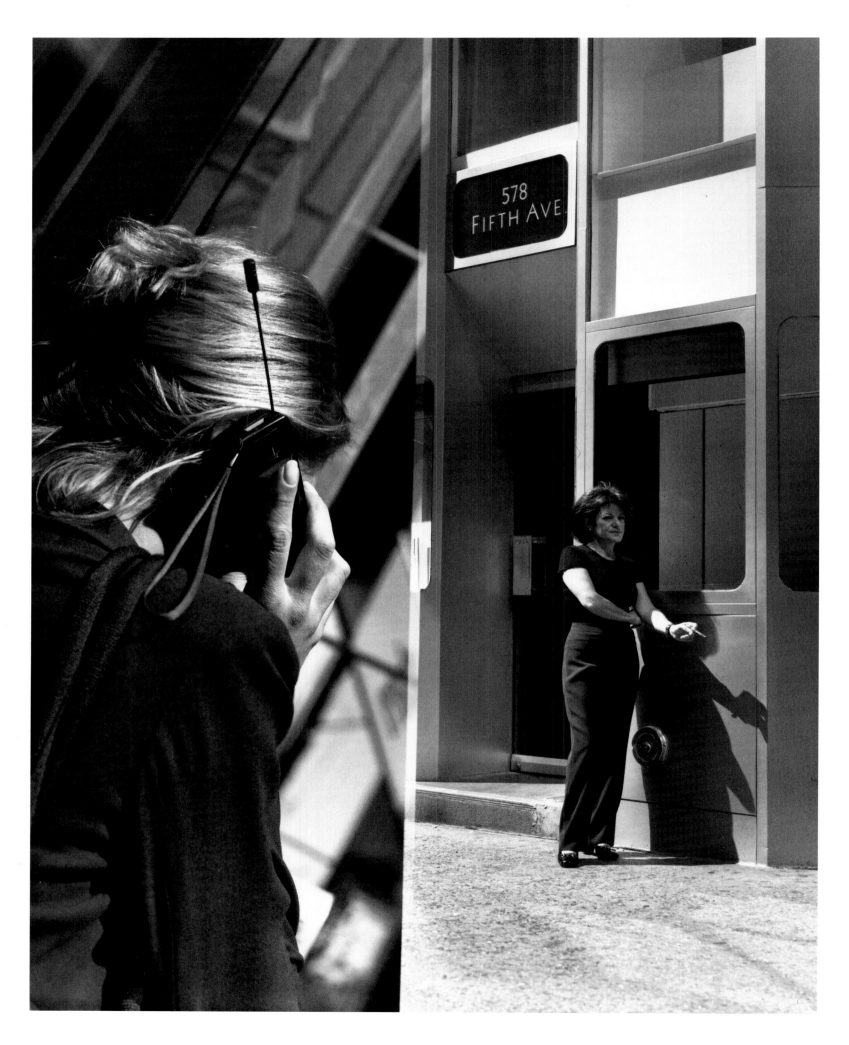

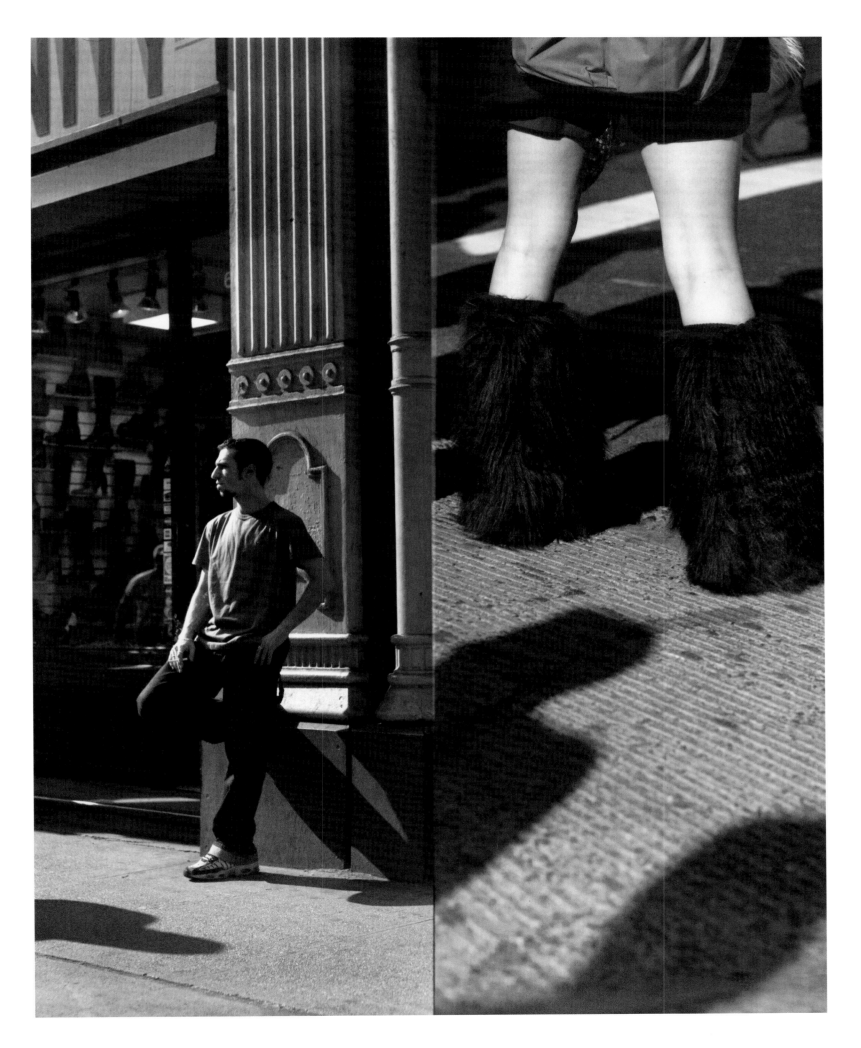

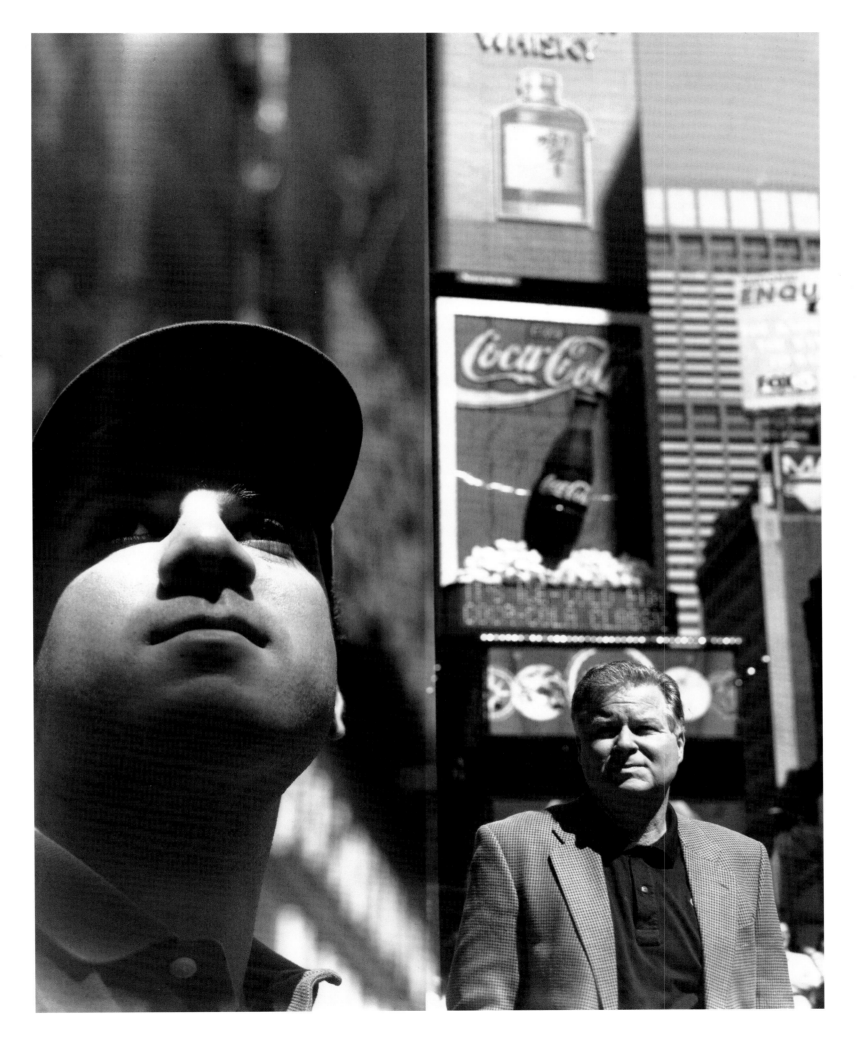

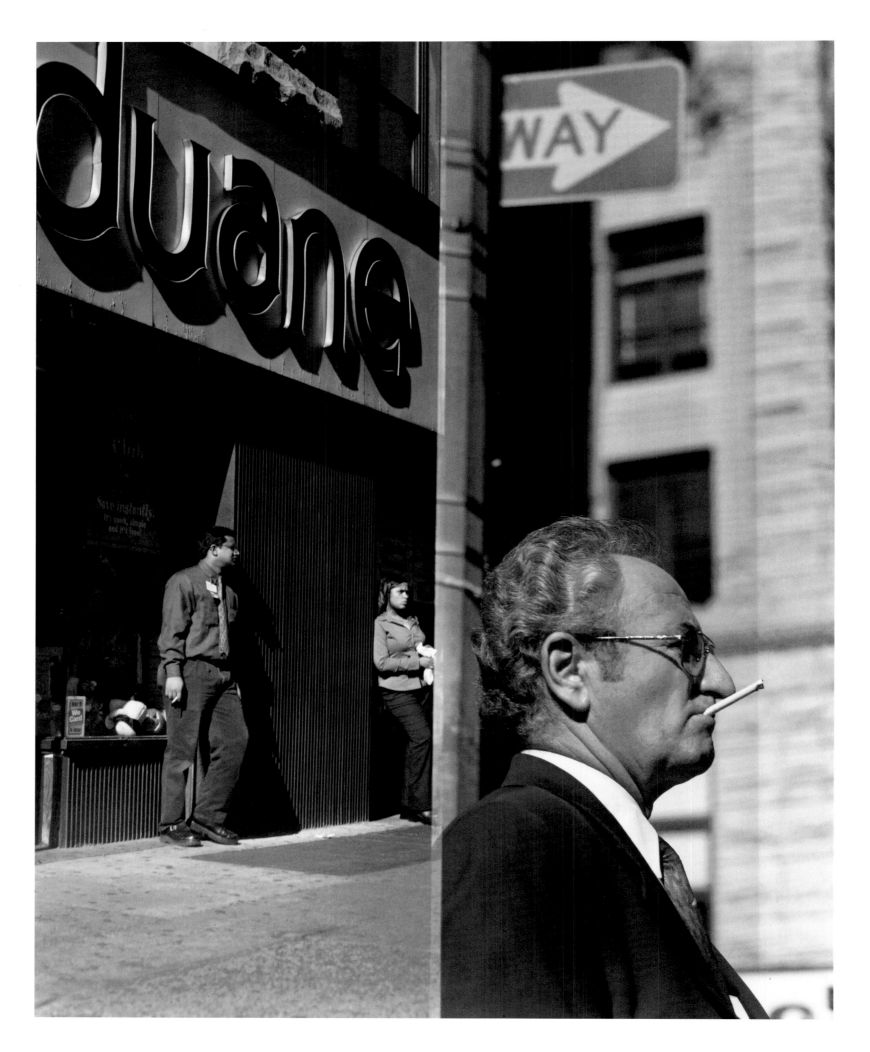

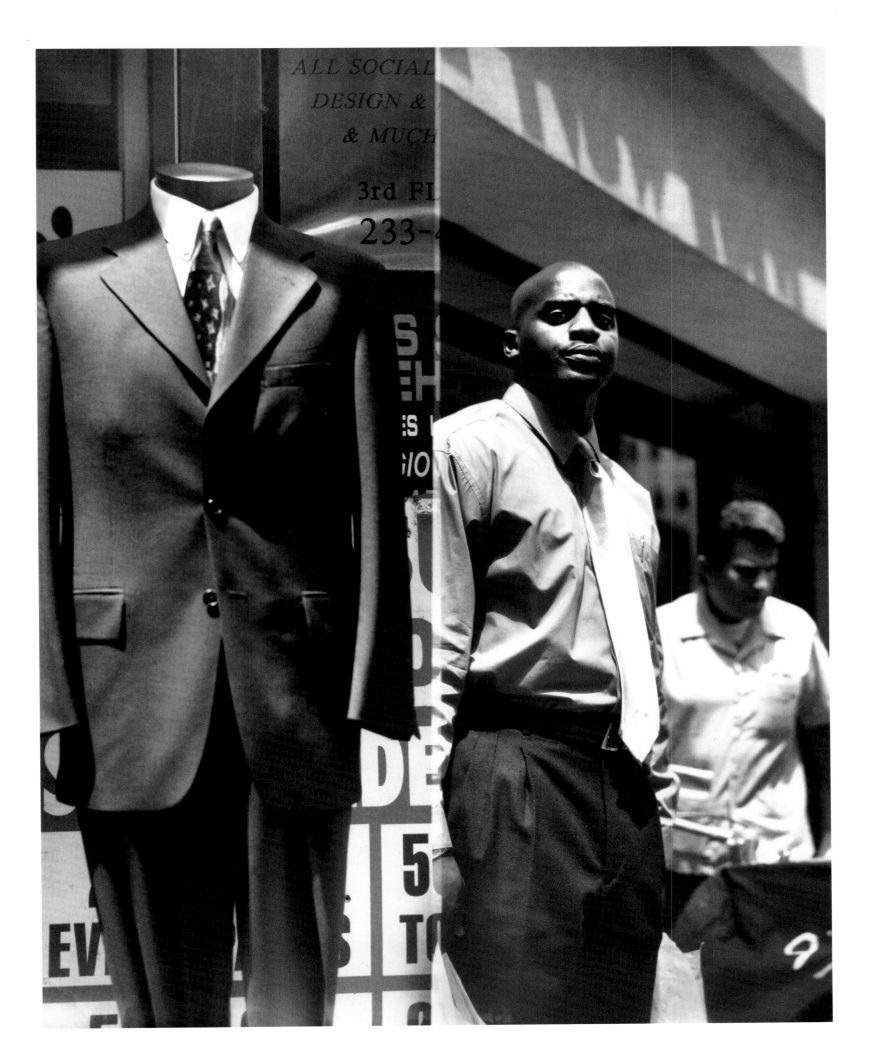

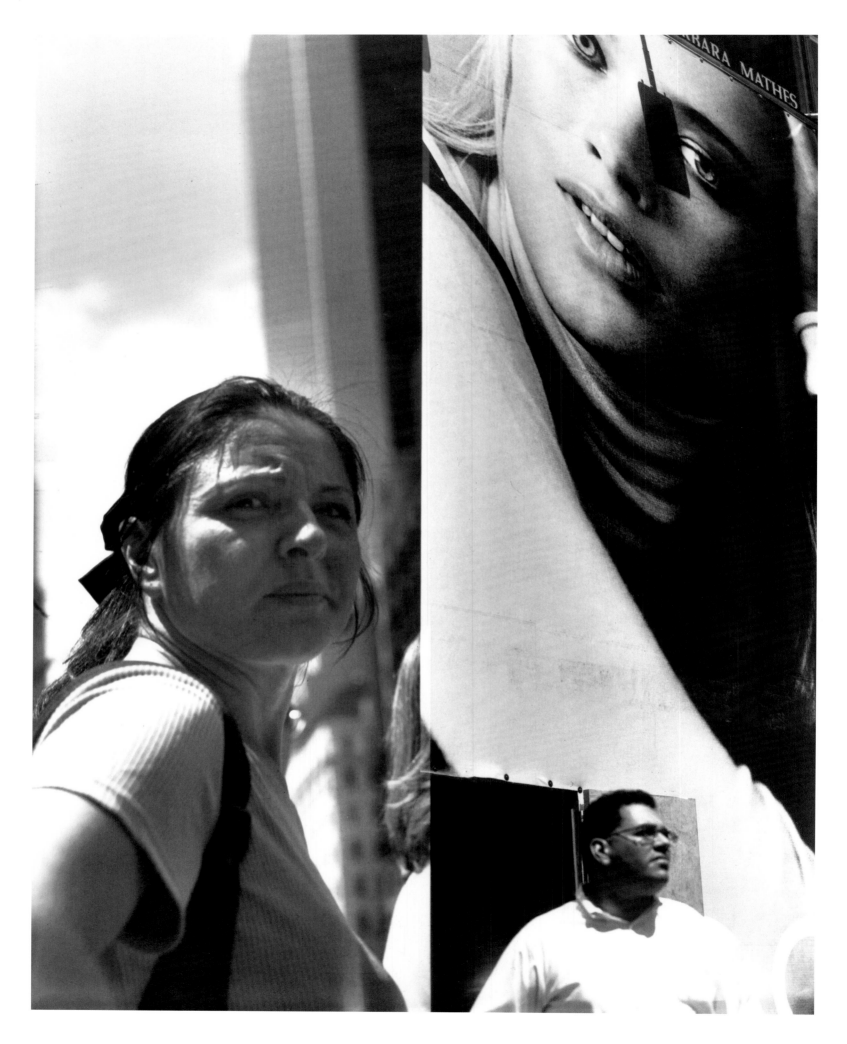

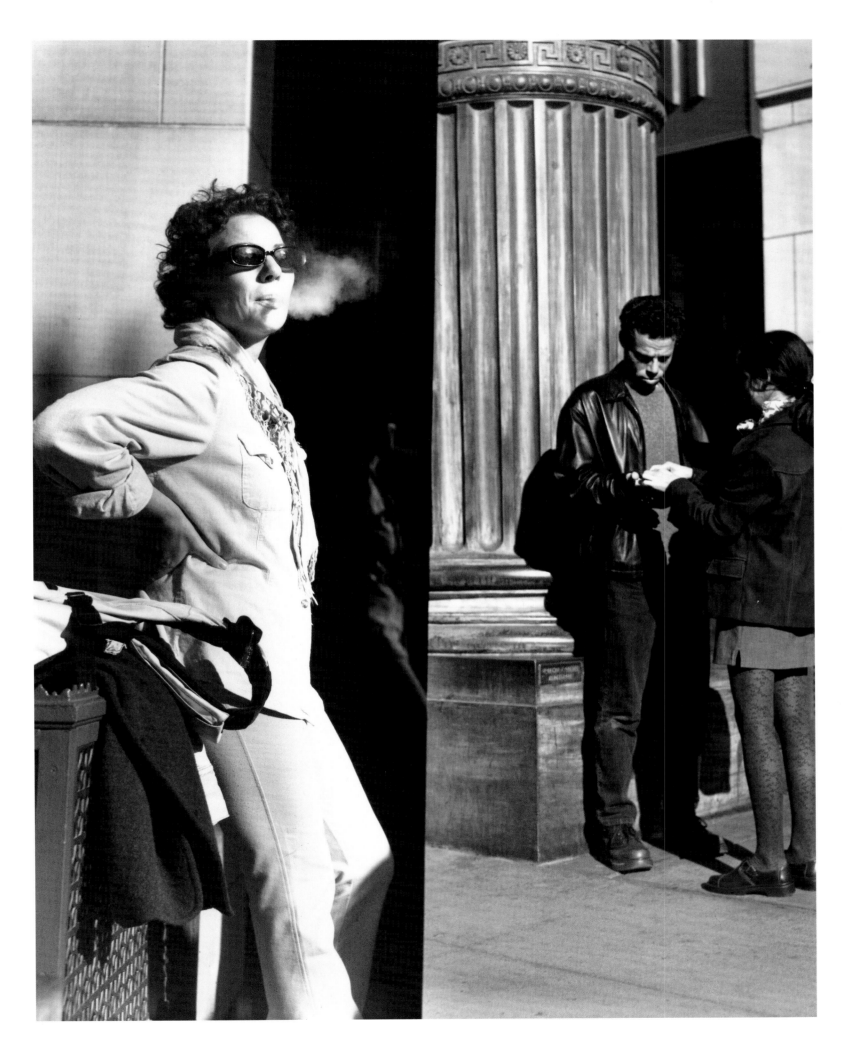

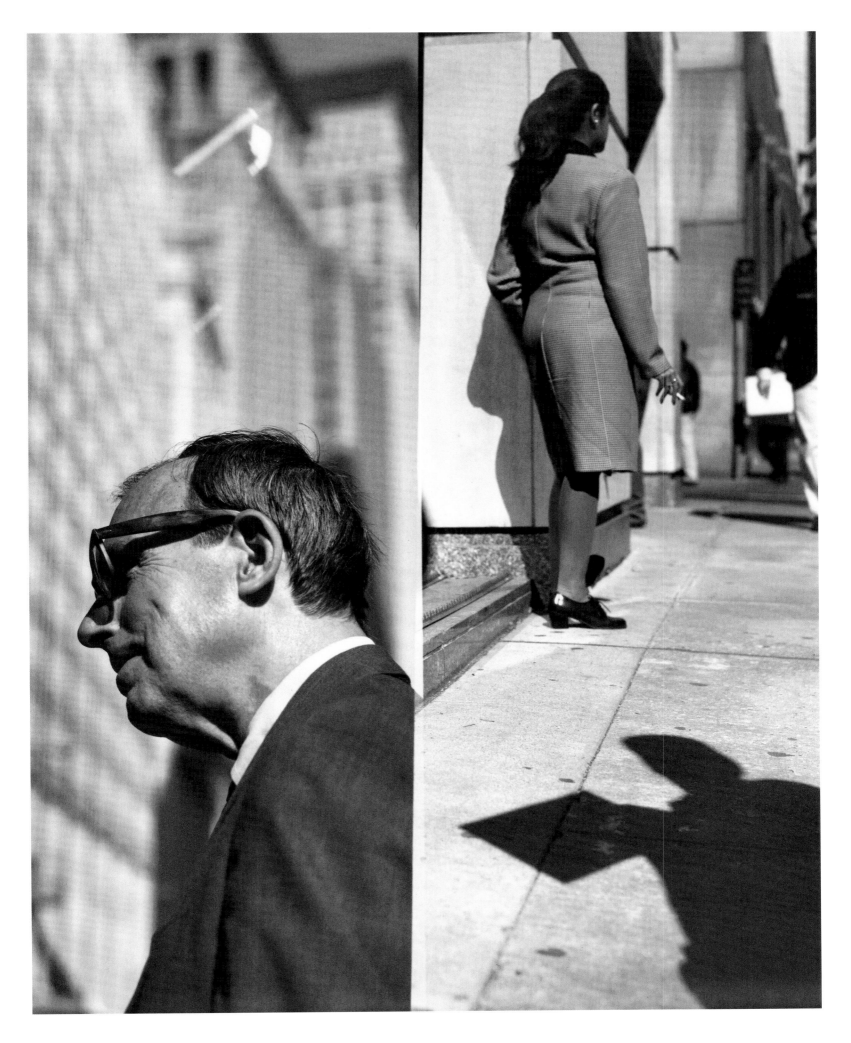

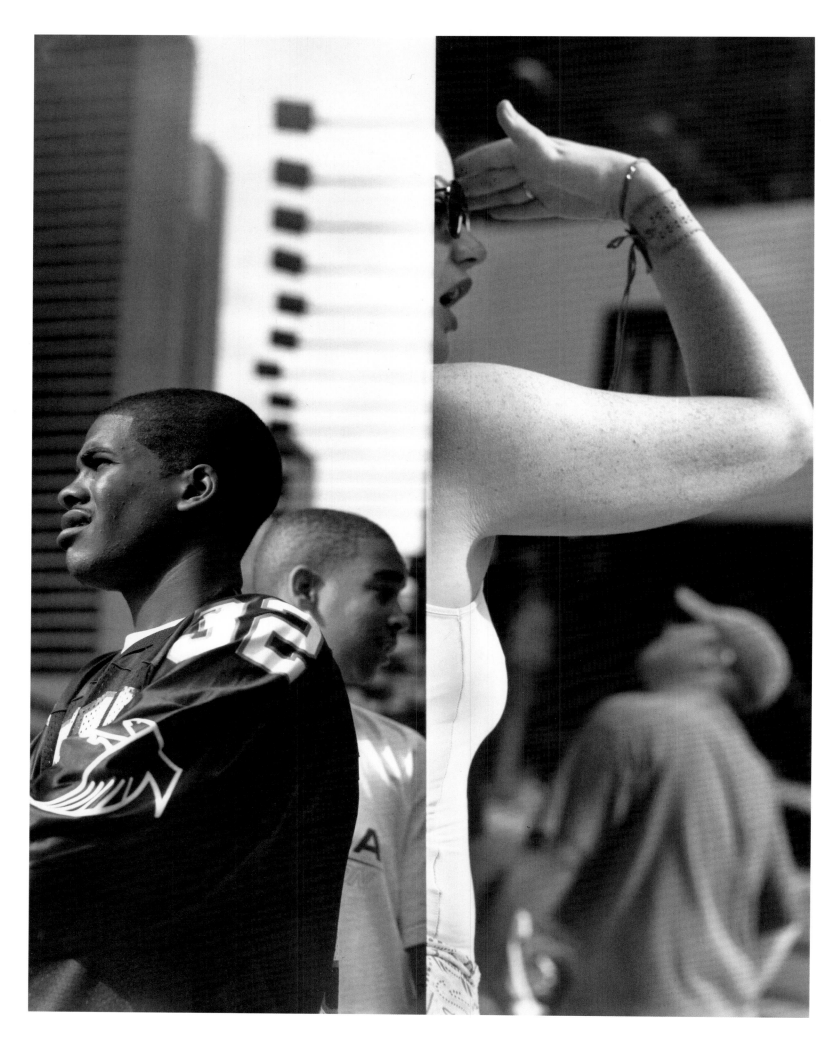

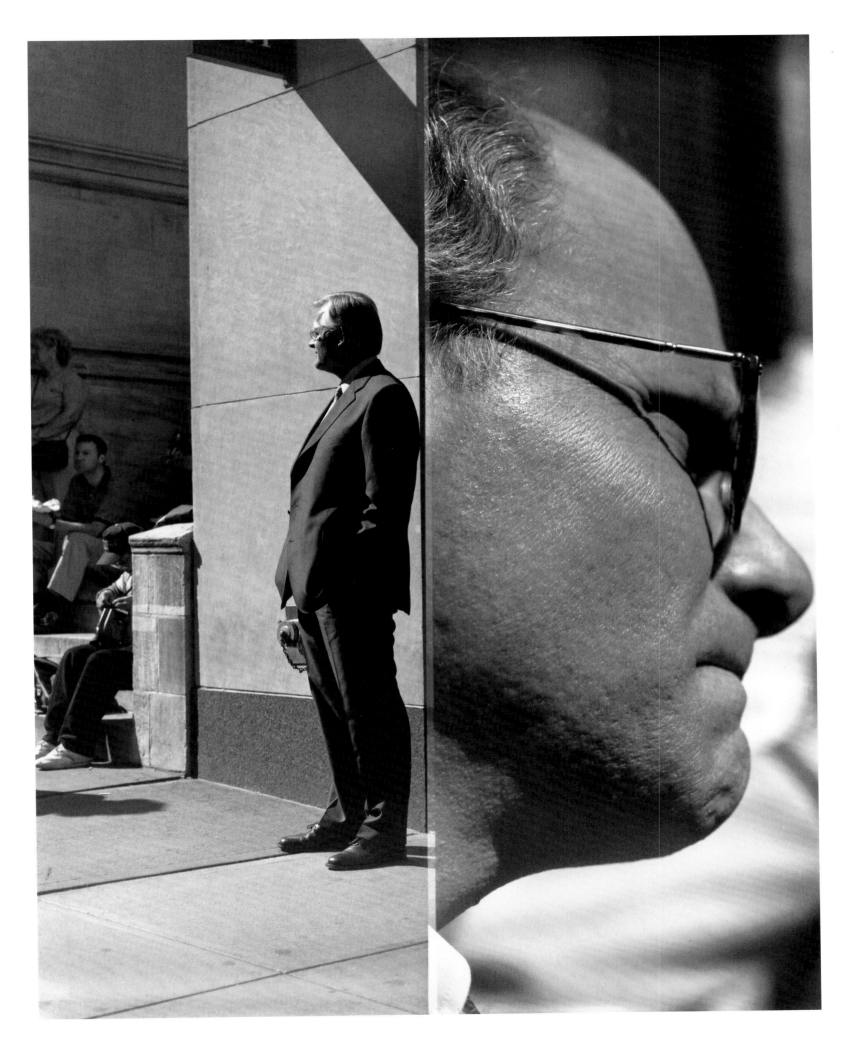

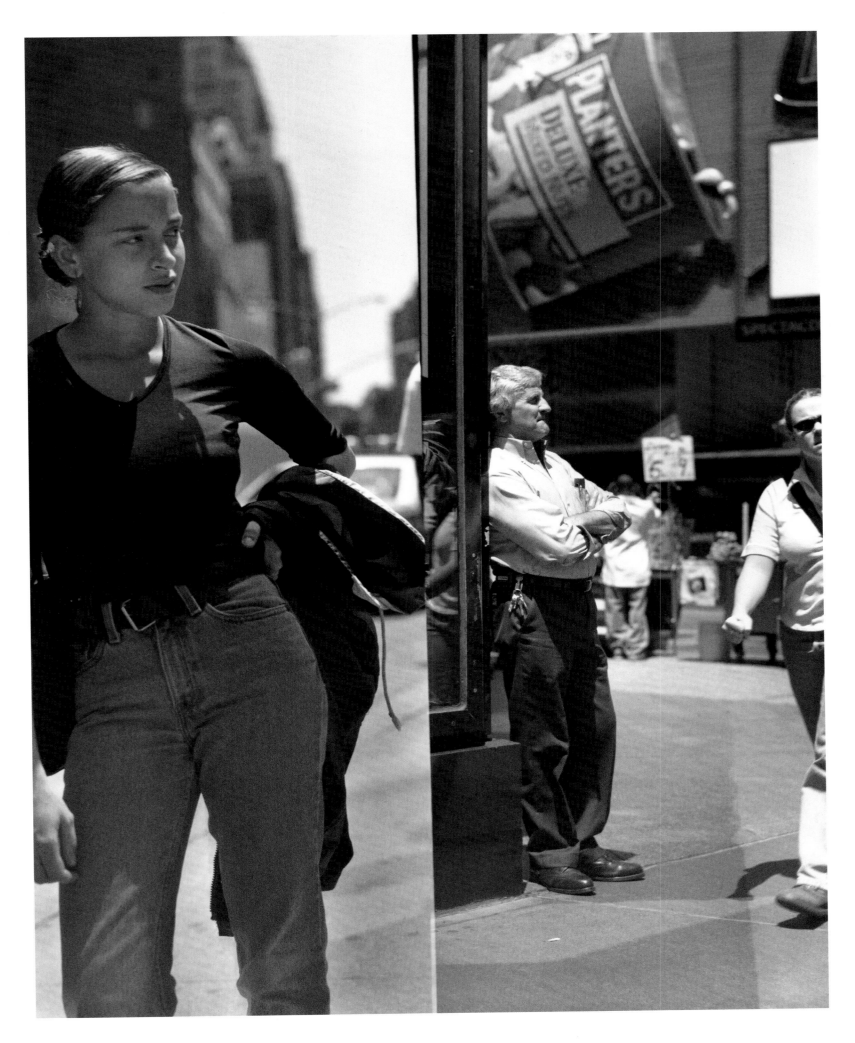

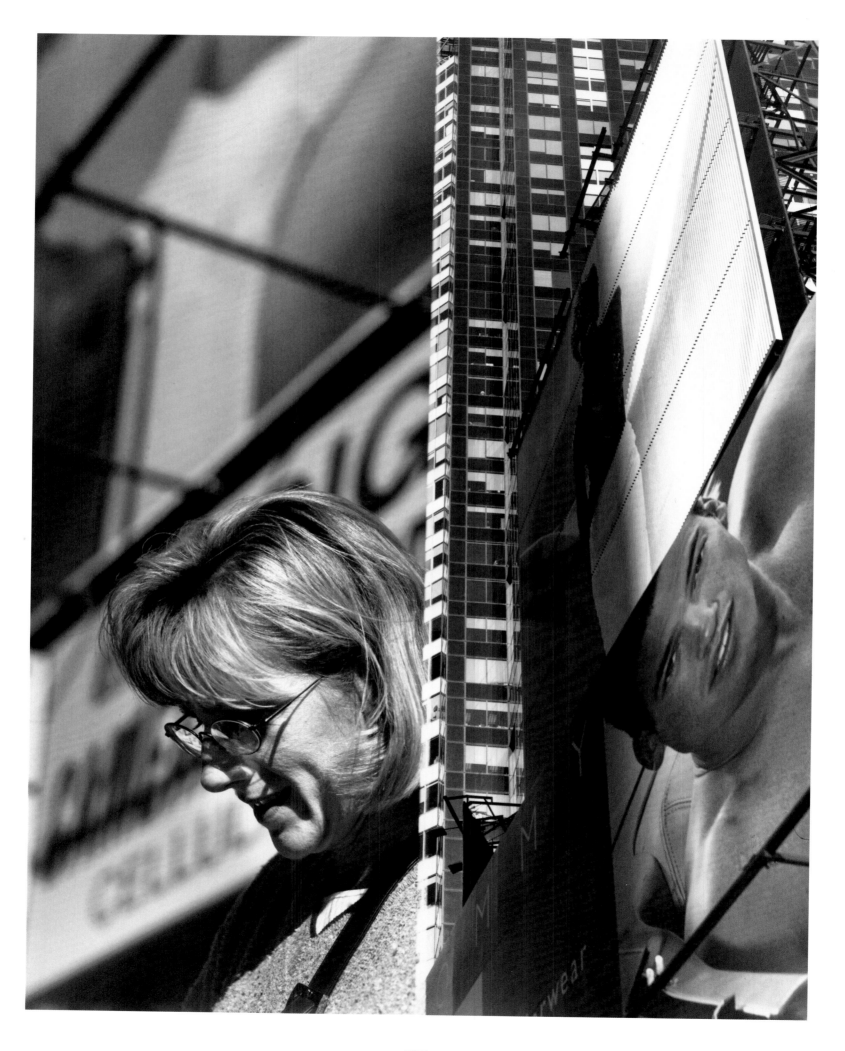

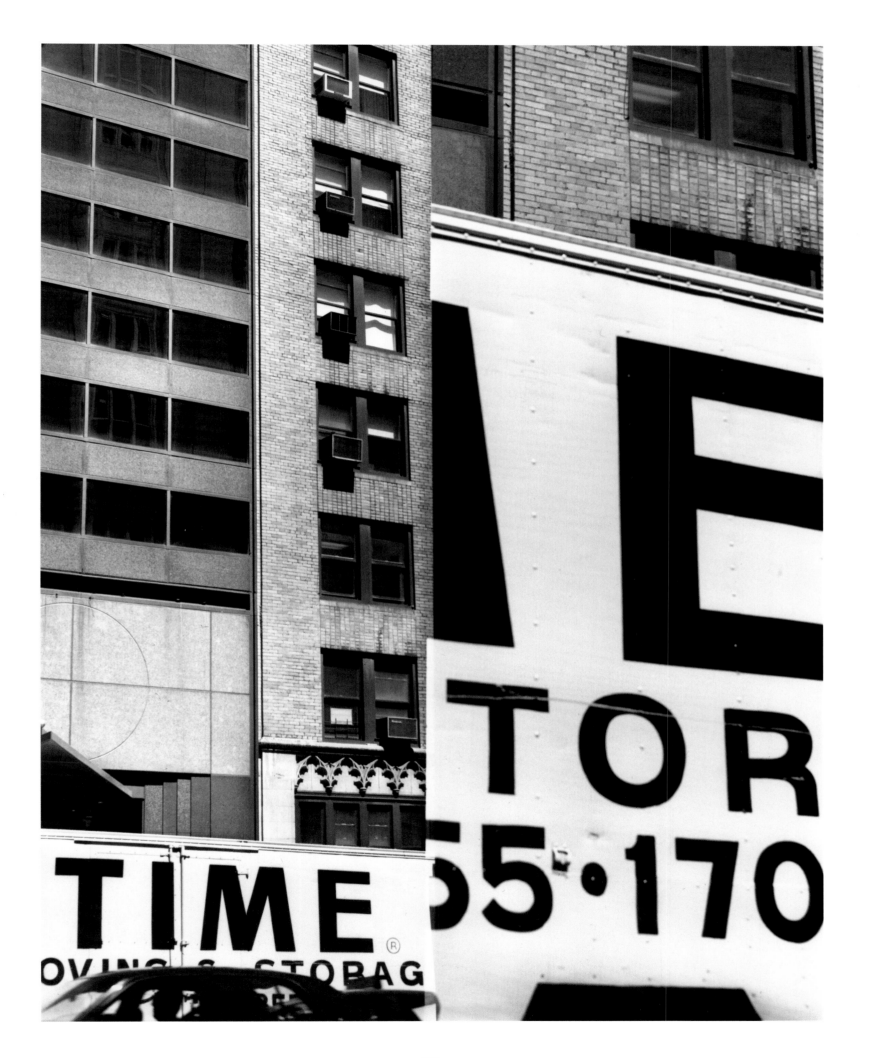

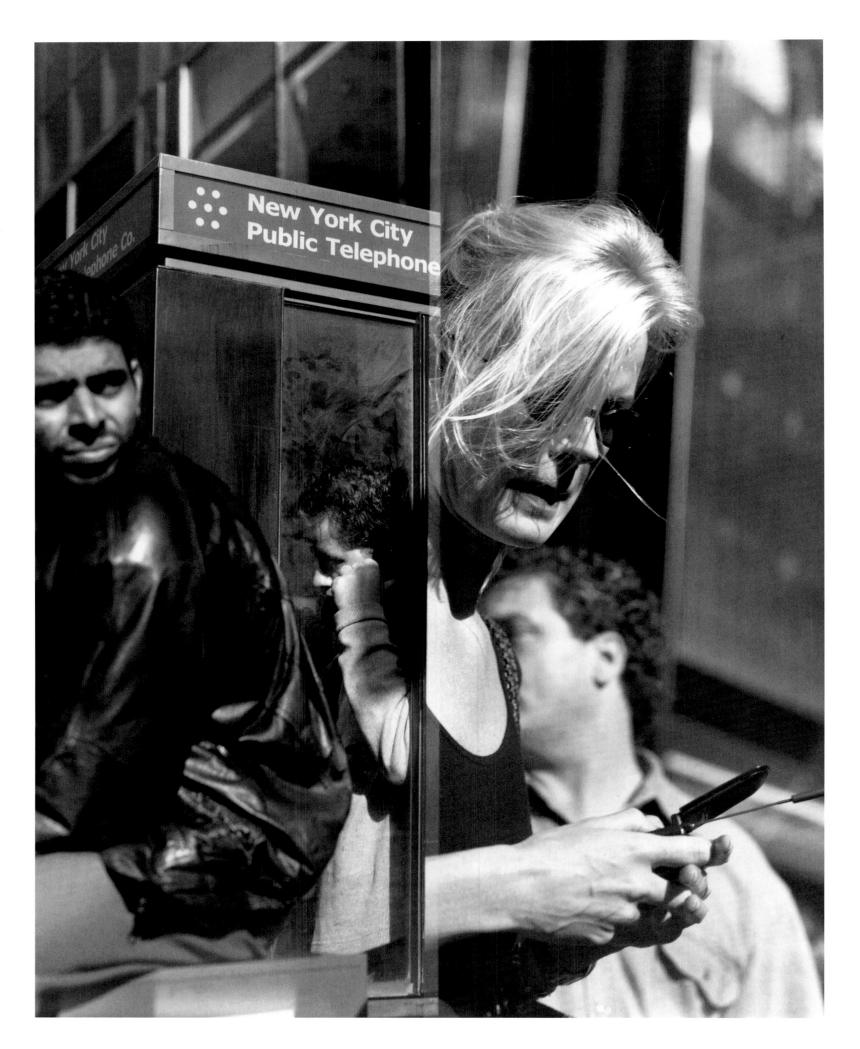

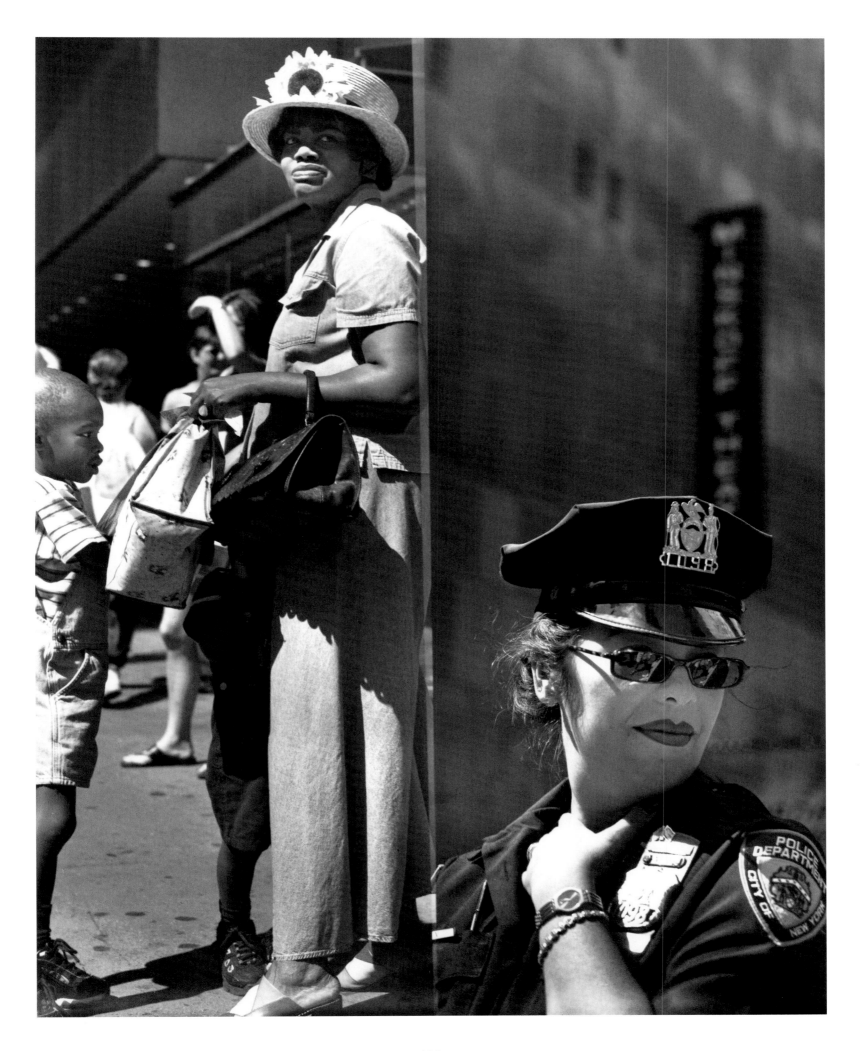

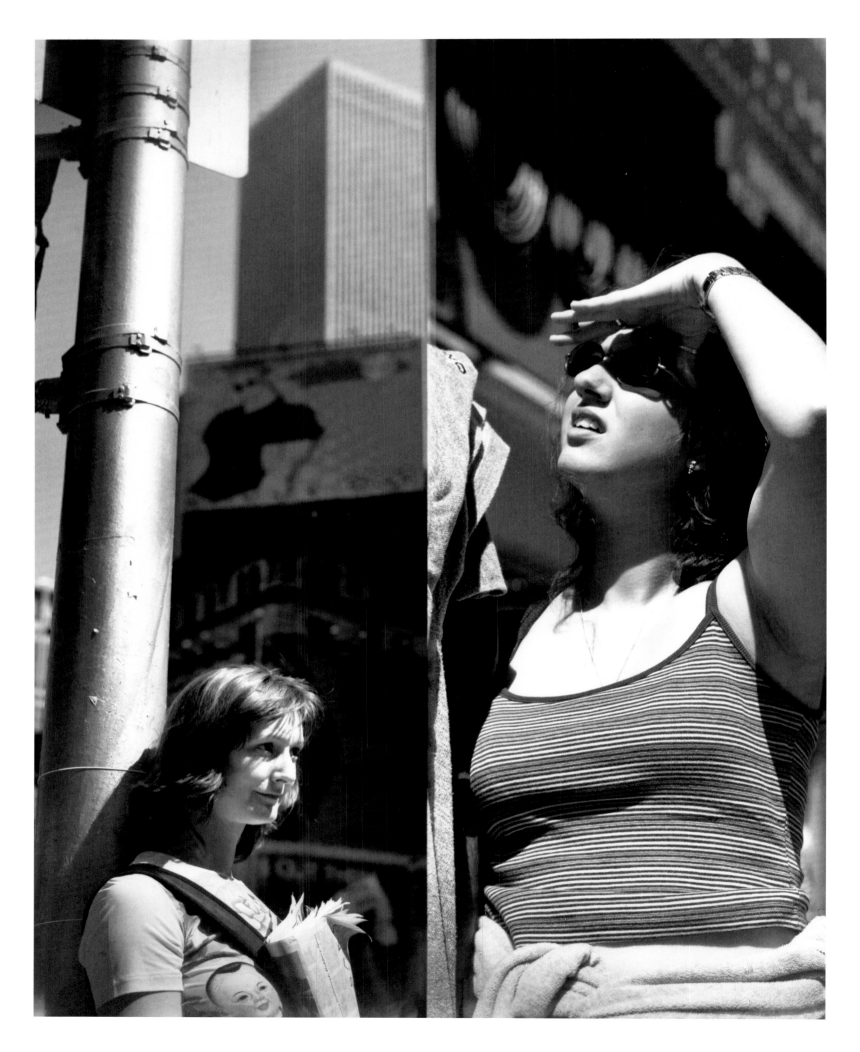

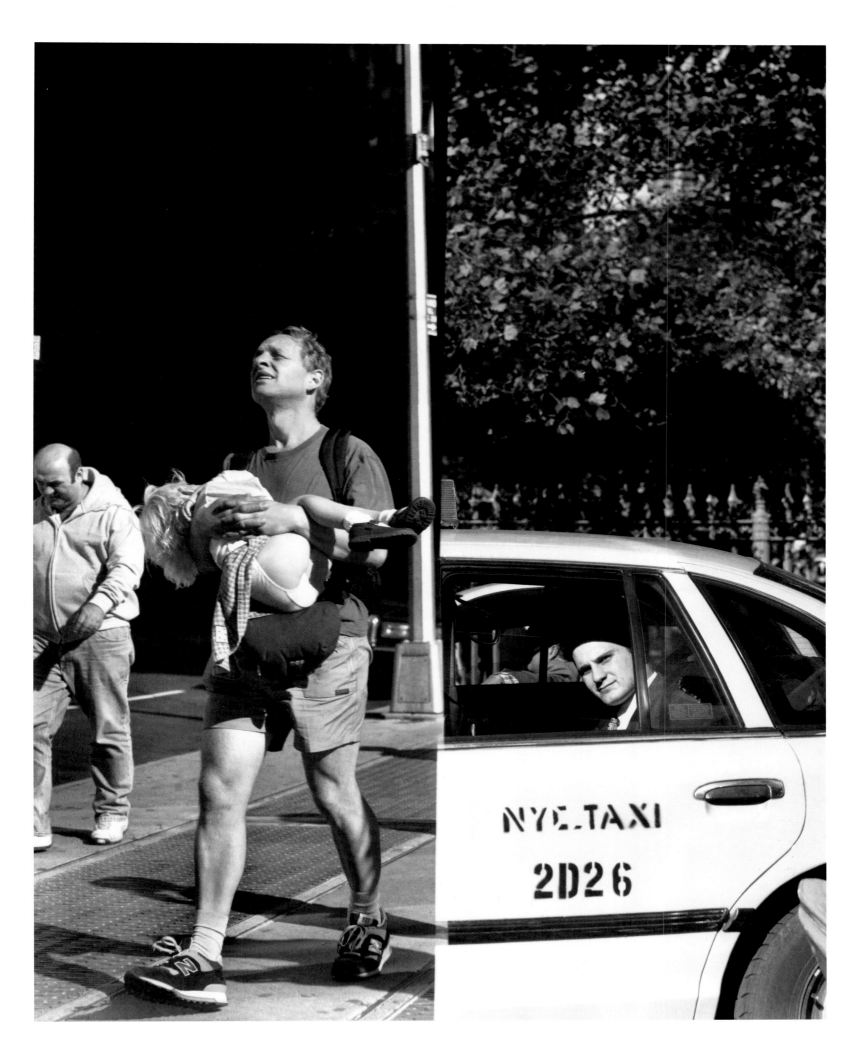

Artist's Note

The five chapters in *Time Frames: City Pictures* represent my perception of the urban experience structured through a range of concepts pertaining to camera vision and temporality. The city, with its densely populated streets, diverse architecture, and overall vibrancy, offers an exciting visual field to explore subject, content, and space. I extended these photographic possibilities by emphasizing the notion of time with panning lenses, sequential recordings, altered negatives, overlapping imagery, and diptych formats. I sought to create and define new relations within the conceptual framework of extended duration on a single negative.

More Compositional Space, or 140°. My work has always aimed to organize the frame to include multiple views and moments, but it was the particular difficulties of photographing people with the panoramic camera that structured my inquiry. The elongated camera frame, with its two-point perspectives, encouraged the seamless grouping of figures within 140° of city space. The photographic language of the wide-angle picture had tremendous potential which was further enriched by the time required for the panning lens of the camera to complete its exposure. Thus, the additional element of duration was inflected in the final image. The concept that a photograph could represent more than an instant fascinated me, and became a central interest in my work.

Spatiality into Temporality. After years of photographing strangers with the panorama camera and establishing a dimension of tension between time and space, I began to photograph with a sequence camera to investigate further the idea of extended duration within a single photograph. I adapted an eight-lens camera—originally designed to capture the sequential movement of a subject—to convey grids in order to establish both continuity and disruptions in movement and subject matter. The succession of eight exposures, within a predetermined time of twenty-eight seconds on a single sheet of film, demanded a pre-visualized conceptualization and anticipation of visual incidents as they unfolded. The experience of walking down a street, looking left, right, up, and down while moving in and out of situations was like a cubist jazz riff, a response to the city that described my non-linear movement through urban spaces.

Construction: Timing the Process. The populated panoramic vistas and the eight-part topsy-turvy grids reinforced my interest in developing temporality through the frame of a negative. This led me to portraits, and focusing more closely on individuals. Through the timed process of solarizing negatives, specific details were altered, and subjects appeared in a vague and hazy environment of urban information. Reversals of tones, etched lines, and manipulated shapes that bled into one another transformed looming faces, striding figures, and urban architecture into otherworldly realities. Spaces of ambient gray and zigzagging lines highlighted the people, capturing them in isolated moments of reflection amid the crowded urban landscape.

Urban Simultaneity. The solarization techniques and varied perspectives of the panoramas and grids are reintroduced in the multi-exposures. Achieved by repeatedly exposing the same sheet of film, these layered compositions orchestrate select intervals by recombining the cacophony of city activity into assembled montages. The city's jarring pace is registered through shifts in scale, combinations of interior and exterior spaces, positive and negative tones, and blurred and sharp depictions to evoke the simultaneity of the urban experience. Like the draft marks in a sketch, figures, faces, hands, gestures, and words reappear or disappear through a dense overlay of concurrent images. As the passage of time is compressed, a single viewpoint gives way to a multiplicity of overlapping perspectives.

Time: Referential to Itself. The diptychs fuse two separate instants onto a single sheet of film. These images recall the elongated rectangles reminiscent of the earlier panoramas, but with the distinct moments of the eight-part grids. The verticality of the city is emphasized through the split of the dual frame, which weighs subjects in equal measure. Individuals are defined and redefined through shifts in space and depth, as two frames create a new dynamic through the interplay of multiple entry and exit points. These separate moments, united in-camera, create compositions of urban duality.

The panoramas, eight-part grids, portraits, multi-exposures and diptych formats included in *Time Frames* represent a selection taken from a twenty-five year exploration of urban space, with its complex temporal and spatial constructions. It is not an exercise in form, but rather an examination of active perception mediated through the process of still photography.

—Michael Spano
New York City
May 2002

Plates

Acknowledgments

My gratitude goes to Howard Stein, whose generosity and faith in my photography helped make this project possible.

I am grateful to the following institutions who have, over the years, sponsored my work: Art Matters, CameraWorks, JGS Inc., The John Simon Guggenheim Memorial Foundation, Light Work, The New York State Foundation for the Arts, and The Sarah Lawrence Marilyn Simpson Faculty Support Grant.

For their guidance and support throughout my career, I wish to express my gratitude to: Patricia Branstead, Arthur Cohen, Larry Fink, Louis Finkelstein, John T. Hill, Itzik Kasovitz, Robert Menschel, Dennis Myers, Susan Rowland, Tony Sifton, Robert Simon, and William E. Williams.

For the many valuable suggestions by friends and colleagues in the creation of this book, my thanks to: Lois Conner, Peter Galassi, Welfhard Kraiker, Ari Marcopoulos, Matthew Postal, Thomas Roma, Sy Rubin, Alan Siegel, Jutta Simson, Pari Stave, John Szarkowski and Andrew Wilkes.

I value the commitment to my work by Laurence Miller, Vicki Harris, and the staff at the Laurence Miller Gallery.

Special thanks go to Susan Kismaric for her discerning introduction; Alice Rose George for her advice and encouragement throughout this project; Laurie Monahan for her insight and editorial contribution to my text; Thomas Palmer for his artful expertise in preparing the separations; my publishers Daniel Power and Craig Cohen for their belief in this book; Kiki Bauer for her help with the design, and everyone at powerHouse for their assistance.

I am especially grateful to my mother Edith, my grandmother Rose Kreisler, my sister Donna DeMar, and my father Louis for their loving support; to my brother Lance for our ongoing dialogue about art; and most of all, I am thankful for the unwavering support of my wife Gabriela Humpke Spano.

—Michael Spano
June 2002

TIME FRAMES
City Pictures

Published in the United States by powerHouse Books,
a division of powerHouse Cultural Entertainment, Inc.
180 Varick Street, Suite 1302, New York, NY 10014-4606
telephone 212 604 9074, fax 212 366 5247
e-mail: timeframes@powerHouseBooks.com
web site: www.powerHouseBooks.com

First edition, 2002

Library of Congress Cataloging-in-Publication Data:

Spano, Michael, 1949-
 Time frames : city pictures / photographs by Michael Spano ; text by Susan Kismaric.
 p. cm.
 Exhibition at the Laurence Miller Gallery, New York, November-December 2002.
 ISBN 1-57687-140-1
 1. Photography, Artistic--Exhibitions. 2. Spano, Michael, 1949---Exhibitions. 3. New York (N.Y.)--Pictorial works--Exhibitions. I. Kismaric, Susan. II. Laurence Miller Gallery. III. Title.

 TR647 .S694 2002
 779'.092--dc21

 2002068440

Hardcover ISBN 1-57687-140-1

Duotone separations by Thomas Palmer
Printing and binding by EBS, Verona
Design associate, Kiki Bauer

A complete catalog of powerHouse Books and Limited Editions is available upon request; please call, write, or frame our web site.

10 9 8 7 6 5 4 3 2 1

Printed and bound in Italy